Enchanting
LANGKAWI

DAVID BOWDEN

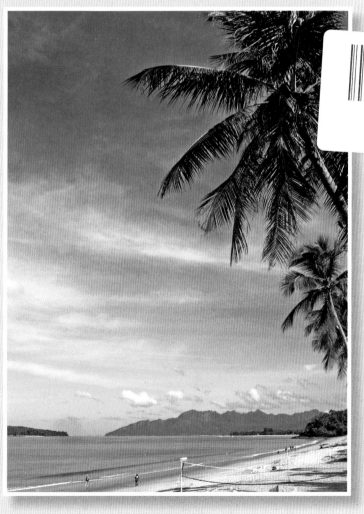

JOHN BEAUFOY PUBLISHING

The Frangipani Langkawi
Resort & Spa

The Langkawi archipelago of 99 islands became the world's 52nd UNESCO Geopark in recognition of its many unique and ancient geological features. This acknowledgement and branding is being used to help preserve Langkawi's many natural assets which contribute to the island destination being different from most other islands in the region.

Langkawi's main island is smaller than Singapore and has only 65,000 inhabitants who were once mostly *padi* farmers and fishermen. Tourism on Langkawi only started about 20 years ago and is now the main job provider on the island.

Many tourists travel to Langkawi to admire its beautiful natural forests, waterfalls, caves, outer islands and tranquil sea. Activities in nature such as jungle trekking, bird watching, island hopping and exploring the fascinating mangrove forests appeal to many visitors. Others come to indulge in luxurious resorts and to enjoy fine food and therapeutic spa treatments. Duty-free shopping appeals to many visitors.

With the production of this comprehensive book on Langkawi, you too can enjoy the amazing natural beauty of these magnificent islands of Langkawi, Malaysia.

Enjoy your reading.

Anthony Wong
Managing Director
Frangipani Resort and Spa
Langkawi Island
Malaysia.
www.frangipanilangkawi.com

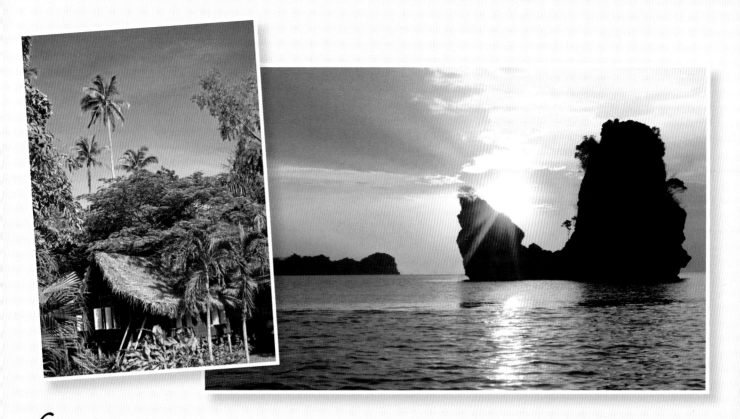

Contents

Above left: Bon Ton Resort offers luxurious accommodation in antique houses that have been relocated and restored from all over Peninsular Malaysia.

Above right: While the Langkawi Archipelago consists of 99 islands some are mere specks on the horizon.

Title page: Palm-fringed Pantai Tengah is one of Langkawi's most picturesque beaches.

Chapter 1: Naturally Langkawi

Langkawi Island (Pulau Langkawi) is arguably Malaysia's finest island holiday destination. The term island (*pulau* in Bahasa Malaysia) is a little misleading in that there are actually 99 islands in the Langkawi archipelago although some references suggest the total is 104. The largest island and the one where most people will holiday is also called Langkawi.

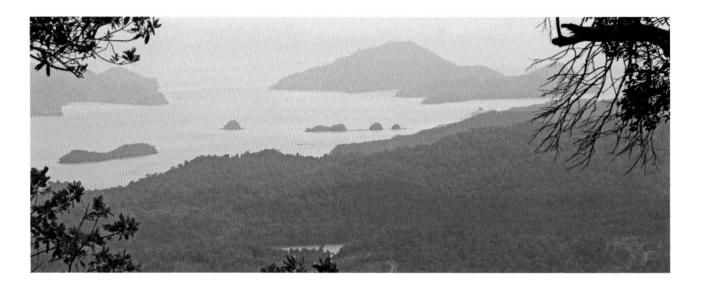

The islands are part of the state of Kedah and the small ports of Kuala Kedah and Kuala Perlis on the mainland are the gateways for those travelling to the island by ferry. By plane, visitors fly in across the Andaman Sea into Langkawi International Airport and get an amazing aerial view of a clutch of emerald green islands. Most of the islands are still covered in luxuriant tropical rainforests and coastal mangrove forests while coral reefs are found offshore. Even on the main island, where most of the island's 65,000 residents live, much of the island is still covered in vegetation and few buildings rise above the height of a coconut tree.

Life on the island moves at an unhurried pace and is very different from the other major tourist islands of the region, such as Bali and Phuket. Langkawi is also home to many plants and animals and much of its natural assets are protected as a UNESCO World Geopark. It is a community of rice farmers and fishing folk who have resided here for centuries. Tourism is an important industry but it has only been in the past two decades that this has really developed, including the building of an international airport and a cruise ship terminal. Langkawi has attained a balance between maintaining traditional life, protecting the environment and its modern infrastructure.

Several island-specific events also attract tourists. Langkawi is the venue for the Langkawi International Maritime and Aerospace Exhibition (LIMA) held every two years in March on odd years. It showcases state-of-the-art aviation and marine defence technologies and includes exhilarating in-air and on-water displays for visitors. Other events of note include the Royal Langkawi International Regatta in mid January and the Raja Muda Selangor International Regatta contested in mid November.

Apart from the main town of Kuah and the development along several of the main beaches (known as *pantai*), the other settlements are mostly small villages or *kampungs*. Most of the natural vegetation remains intact.

The islanders are open and interested in visitors and as such are welcoming and friendly. Many work in the tourism industry and their command of English is good although the islanders mostly converse amongst themselves in the local language of Bahasa Malaysia. They are justifiably proud of the wonderful range of achievements as well as dining options on the island and are pleased to direct visitors to their favourite hawker stall.

It is Langkawi's range of natural habitats, laid-back lifestyle and multicultural spirit that makes it such a popular international island holiday destination.

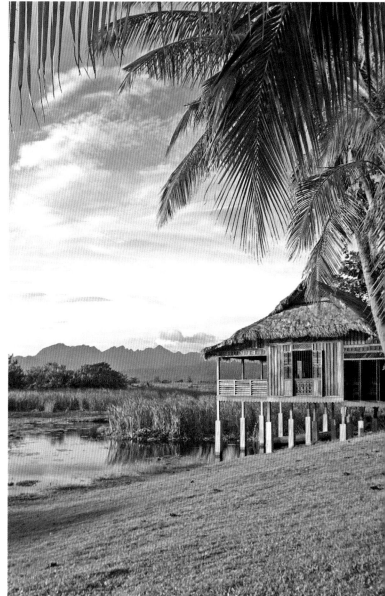

Left: Visitors to Langkawi are spoilt for choice with a delicious range of cuisines served in luxurious restaurants and roadside hawker stalls.

Opposite: Of the 99 islands, only three are populated; the remainder are covered in tropical rainforest.

Above: Traditional Malay houses are built on stilts for better ventilation. This antique wooden house at Bon Ton Resort has panoramic views over a reed-lined wetland and serves as a restaurant.

Geography and Climate

The islands of Langkawi are situated some 50 km (31 miles) to the west of the coastline of north-west Peninsular Malaysia. The archipelago is very close to the maritime border with Thailand to the north and, immediately to the west, across the Andaman Sea, is the Indonesian island of Sumatra. The Malaysian island and state of Penang is situated 110 km (68 miles) to the south of Langkawi. Langkawi itself is a tropical island with the map coordinates of 6° 21'N and 99° 48'E.

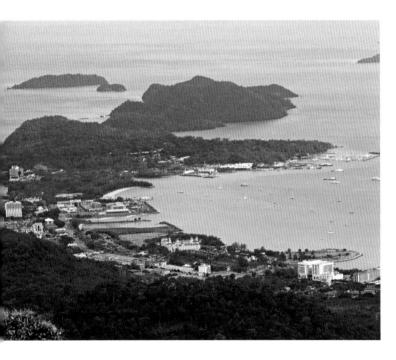

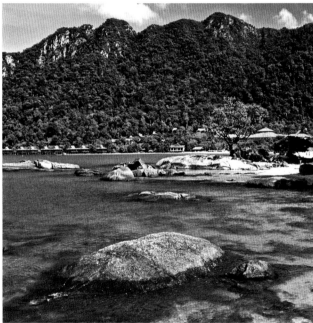

The Langkawi archipelago covers an area of 478 km² (185 sq miles) with the main island measuring approximately 20 by 30 km (12 by 19 miles). Two peaks (known as *gunung* in Bahasa Malaysia) dominate the main island with Mount Raya being the highest at 880 m (2,887 ft) and Mount Machincang next at 713 m (2,239 ft). Other islands are so low that they disappear during the high tide and may lead to the confusion as to how many islands there actually are in the group. The main island is 300 km² (116 sq miles). By comparison, Singapore is 712 km² (274 sq miles) and Penang 1,048 km² (405 sq miles).

Above left: Kuah, on the south-east coast, is the largest urban area on Langkawi Island.

Above: Many beachfront resorts have steep and dramatic mountains covered in lush rainforest as a backdrop.

Opposite: Mount Raya towers over lush rainforests, wetlands and fields of rice that thrive in Langkawi's moist, tropical climate.

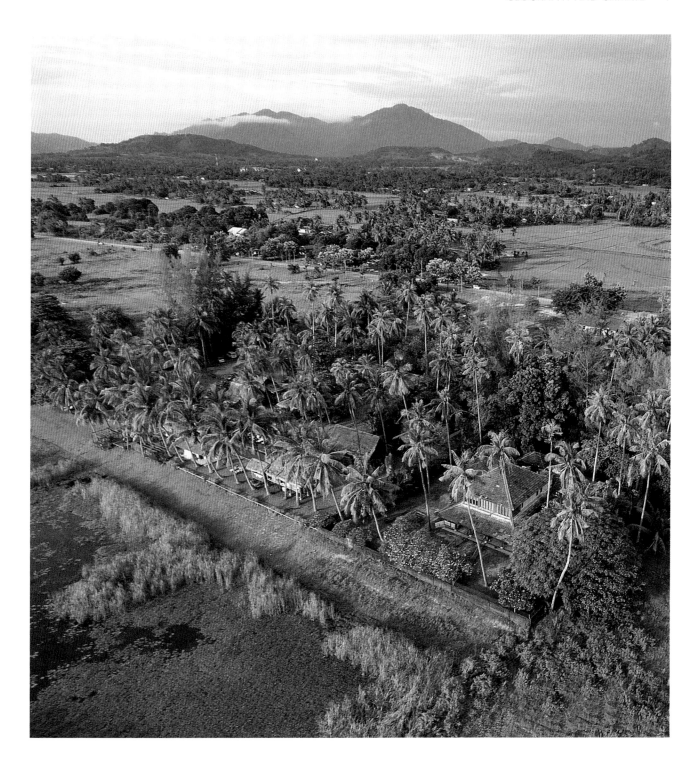

The archipelago's climate is classified as equatorial, which means it is typically warm and wet throughout most of the year, however Langkawi does have a distinct dry season. The region's climate is dominated by the monsoon (the movement of winds which result from the differences in temperature over the sea and land). The north-east monsoon brings most rain from November to March and the south-west monsoon delivers rain from May to September. Most rain falls in Langkawi during the south-west monsoon with the dry season being from December to March.

History

Historical records suggest that Kedah has been visited by foreign mariners since the fifth century when traders from Persia, Arabia, Southern India and Africa sailed easterly on the monsoon winds across the Indian Ocean. Kedah is on a similar latitude to the southern tip of the Arabian Peninsula, north-eastern Africa and the southern tip of the Indian subcontinent, so mariners were able to set off on the monsoon winds from June to November. They traded glassware, cotton, camphor, sandalwood and ivory and returned on the reverse monsoon which blows westward from December to May.

Opposite top: Bujang Valley in Kedah on the mainland opposite Langkawi is home to the remains of a Hindu-Buddhist kingdom.

Below: Bujang Valley is Malaysia's richest archaeological site dating back 2,000 years and includes what is considered to be Southeast Asia's oldest man-made structure.

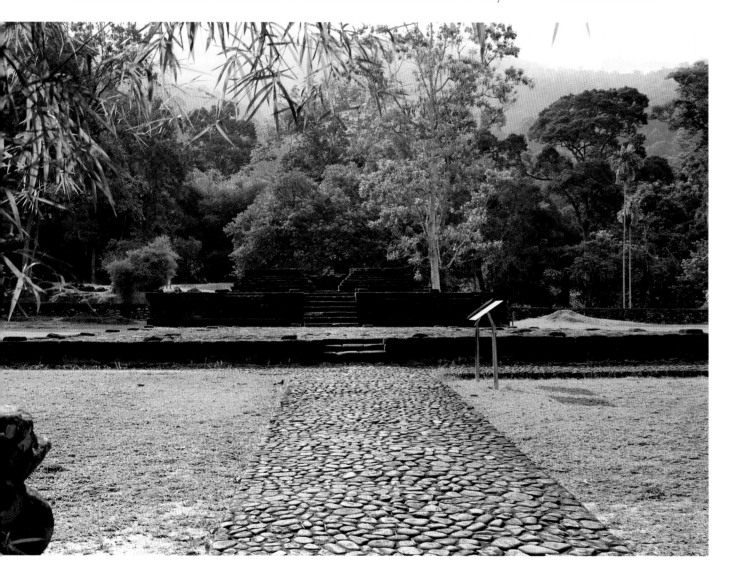

Kedah became the most strategic western port on Peninsular Malaysia where goods were trans-shipped overland to the interior and onwards to China via the present-day southern Thai port of Patani. No doubt vessels moored off Langkawi for protection from storms and to source fresh water.

The Hindu-Buddhist site in Bujang Valley in southern Kedah was the most important Malaysian kingdom some 1,500 years ago. Throughout history, Kedah came under the influence of the Sumatran kingdom of Srivijaya, the Cola Kingdom of South India, Siam (present day Thailand) and the British before Malaysia's independence in 1957.

By the 15th century the Straits of Malacca between Sumatra and Peninsular Malaysia's western coastline were regularly visited by mariners and traders. This vital shipping link connected China and the Spice Islands (Indonesia) with India, Africa and Arabia. Langkawi was strategically located at the northernmost extremity of the Straits. By this time, the town of Melaka (also spelt Malacca) on the mainland had become one of the most important ports in the region.

There are many legends and stories associated with the history of Langkawi. Many locations echo with stories from the past, some strange and others tragic. Some of these are celebrated in specific and scenic locations and whether the legend is believable or not doesn't appear to matter too much to today's traveller. Mahsuri's Curse is the most famous (see page 65).

Many of the sheltered bays and the maze of mangroves provided ideal shelter for pirates who once plundered unsuspecting vessels. While Penang thrived as a major regional port, Langkawi remained very much a sleepy backwater until the then Prime Minister Tun Dr Mahathir Mohamad decided in 1986 to transform the islands within the state where he was born into a premier island tourist destination.

Langkawi Development Authority (LADA) was soon established to oversee the implementation of essential tourism infrastructure. Hotels and resorts soon followed and duty-free status was granted. In 2007, parts of the island were proclaimed a UNESCO World Geopark in recognition of the island's valuable and ancient rock formations.

Tourism development is ongoing but restricted to designated areas so that the bulk of the archipelago remains untouched and the traditional values of the people are unaffected by this development. Langkawi is now branded as 'Naturally Langkawi' to emphasize it as a natural haven and natural choice for tourists.

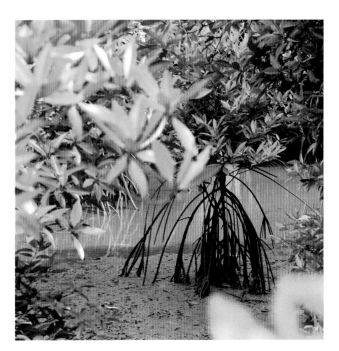

Above: Parts of the coast are lined with mangroves and limestone coves that, in the past, provided a convenient hiding place for pirates.

The People

Only three of the islands of the archipelago are inhabited; these are the main island, Tuba and Rebak. The first two are home to local Malaysians while the 158-ha (390-acre) Rebak Island includes a marina and Rebak Island Resort – a Taj Hotel. There is also limited infrastructure development on Dayang Bunting and Beras Basah Islands.

Right: One of the best locations to experience Malay culture is in the village of Mawat (home to Mahsuri's Tomb) where women wear traditional clothes and play xylophone-based instruments.

Opposite top left: Most Indians were attracted to Langkawi to work in rubber estates and there are several Hindu temples that provide venues for worship.

Opposite top right: While some of the island's residents are involved in tourism, most farm the land and fish the surrounding sea.

Opposite below: The mosque in Kampung Temoyong is typical of most in having a minaret with speakers to call the faithful to prayer.

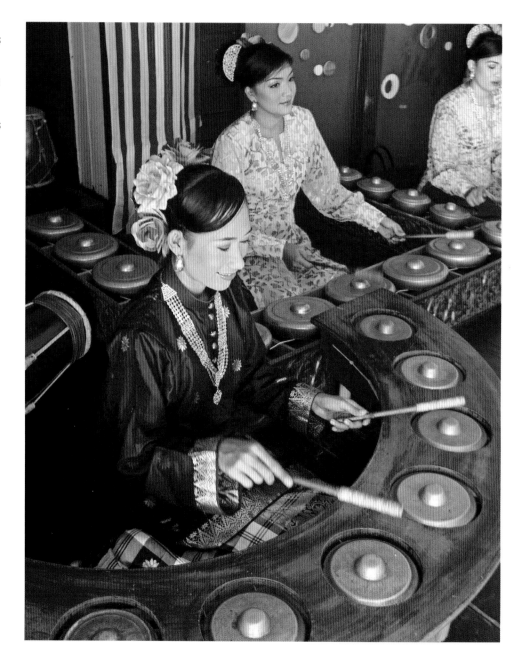

Most of the people living on Langkawi are Malays while others are Malaysians of Chinese, Indian and Thai heritage. Langkawi's multiculturalism is reflected in the island's food, music, art, crafts, customs and religious beliefs. As in the rest of Malaysia, the main religions are Islam, Buddhism, Taoism, Christianity, Hinduism, Confucianism and Sikhism. Such diversity also leads to a colourful array of festivals with the main ones celebrated as national holidays. Muslims mark the end of their month of fasting with Hari Raya; the Chinese celebrate their new year as do the Hindus with their Deepavali festival. Wesak Day is a Buddhist celebration; Merdeka Day on August 31 marks Malaysia's independence and Christians celebrate Christmas Day. However, many people on Langkawi observe an open door policy during the important festivals, inviting friends and relatives to their homes for food and drink regardless of their faith.

The official language is Bahasa Malaysia and this is the most widely spoken but those with a Chinese heritage speak a variety of Chinese dialects and those of Indian descent speak Tamil. English is also widespread especially in the tourist areas.

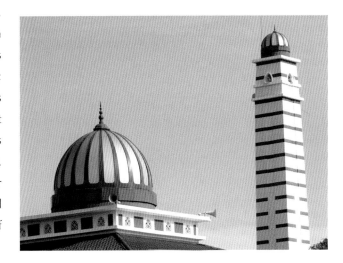

Food

Food is one of the great delights of travel and Langkawi is no exception. Malaysian food encompassing Malay, Chinese and Indian dishes is available everywhere with Malay the most common. Being an island, seafood is freshly caught each day and abundant everywhere. Each afternoon, fishing boats head out to sea and in the evening, the sky twinkles with the distant lights from scores of boats operating in the Andaman Sea. Fish and shrimp farms on the island complement this catch. Fish barbecued over charcoal or *ikan bakar* is very popular.

Malay food, prepared daily, is known for its blend of flavoursome spices in coconut milk. The dishes can be quite hot depending on the amount of chilli: *sambal belacan* (a chilli-based sauce) is a pungent spicy prawn condiment that is added to many dishes. Kedah's history has ensured that Indian and Thai cuisines also have had an influence on local dishes.

Malay food is served everywhere from simple roadside diners to night markets as well as in several fancy restaurants in international resorts. While the food is similar, prices are substantially higher in the latter. For some atmospheric dining in the former, pull up a plastic stool, point to what the locals are eating and enjoy some of the best and cheapest food anywhere in the world. Many hawker stalls and night market stalls specialize in just a few dishes prepared from recipes dating back several generations.

Malaysians love to eat and talk about food so food lovers will be in foodie paradise in Langkawi. Popular local dishes include *satay* (barbecued, marinated meat cubes served on skewers), *nasi campur* (mixed vegetables, meats and rice), beef *rendang* (beef in spicy gravy), *char kway teow* (fried noodles), *roti canai* (fried bread with curry sauce), *nasi lemak* (coconut rice with dried anchovies, egg, cucumber and *sambal*), *pisang goreng* (fried banana) and *ayam perchik* (spicy chicken).

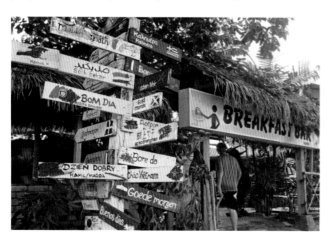

Left: Simple island charm is a feature of famous restaurants such as the Breakfast Bar located along the Cenang Beach strip.

Above: Langkawi excels in stalls offering diners a buffet selection of freshly prepared vegetables, meat curries and fish dishes.

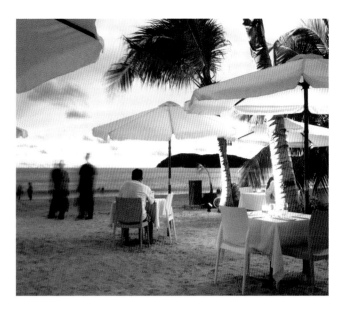

Various regional Chinese and Indian cuisines are available, such as Hakka, Cantonese, Hainanese, Hokkien, Szechuan and Teochow. Most visitors are familiar with the generally mildly spiced Chinese food usually prepared fresh in sizzling woks. Seafood, often prepared from in-restaurant tanks, features in many dishes.

Indian food is known for its spiciness but like Malay dishes, this need not be fiery hot. A popular Malaysian beverage with an Indian heritage is *teh tarik* or 'pulled tea' where a frothy head is created by pouring the tea between two cups before serving.

In addition to local food including Peranakan (a fusion of Malay and Chinese spices and styles), international comfort food plus innovative dishes are also available to cater to the varied palates of foreign travellers and inquisitive locals. While freshly squeezed juices and fresh coconut water are popular with some, beer and duty-free wines are available in many restaurants. Fresh fruit is abundant all over the island.

Above: *Diners can kick off their shoes and dine on the beach to the gentle sound of the waves.*

Below: *'Nasi campur' (mixed rice) is often served on a banana leaf and still offered in restaurants such as Bon Ton near Cenang Beach.*

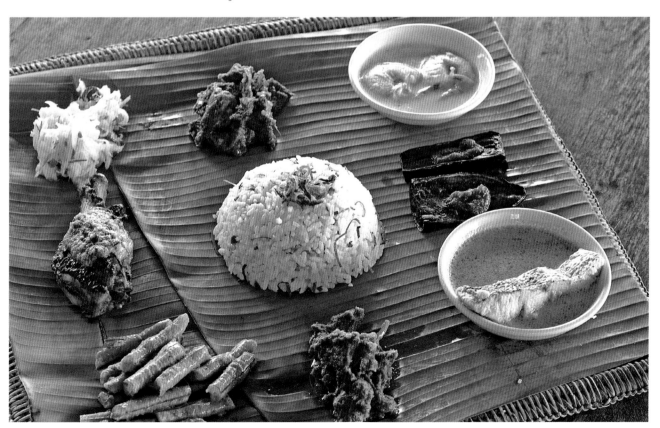

Unique Habitats

Langkawi's tourism marketing initiative 'Naturally Langkawi' recognizes the island's natural assets: its flora and fauna and unique habitats. Central to this is the fact that only three of Langkawi's 99 islands are developed. Even the main and most populated island is carpeted in plants with an estimated two-thirds of the land retaining natural vegetation. The coastal areas consist of flat, alluvial plains which rise to limestone ridges and cliffs.

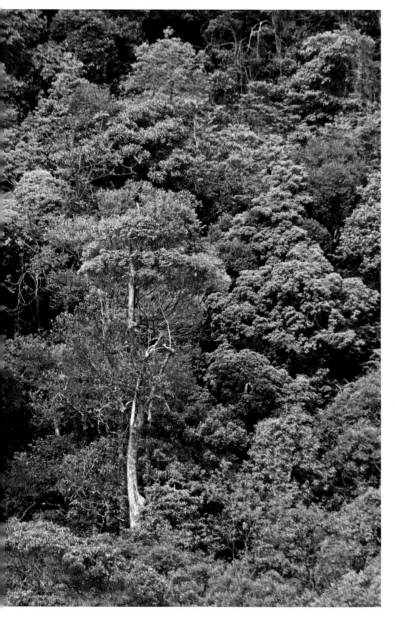

The main habitats are tropical rainforest, wetlands and mangroves, forest on limestone, White Meranti-Gerutu forest and marine ecosystems.

Luxuriant Rainforest

Malaysia's rainforests are some of the world's oldest, tallest and most species-rich. Langkawi's equatorial climate ensures that large tracts of rainforest thrive. The best places to access them are Mounts Raya and Machincang, and Datai Bay. Dipterocarp (those with two-winged seeds) trees dominate the forest. These forests are typically layered with different plant species growing on the forest floor, the understorey, mid-storey and canopy with some emergents. Buttress roots are common as are lianas and vines.

Wetland Wonderland

Parts of the Langkawi coastline are fringed by wetlands that mostly comprise mangroves. Boat tours into the wetlands on the northern and eastern coastline are the most popular nature exploration for tourists. Wetlands form a natural labyrinth of narrow streams and muddy estuaries that are home to animals and a nursery for fish and crustaceans. The maze of mangrove roots also assist in protecting the coastline from erosion. Rice fields are home to many birds.

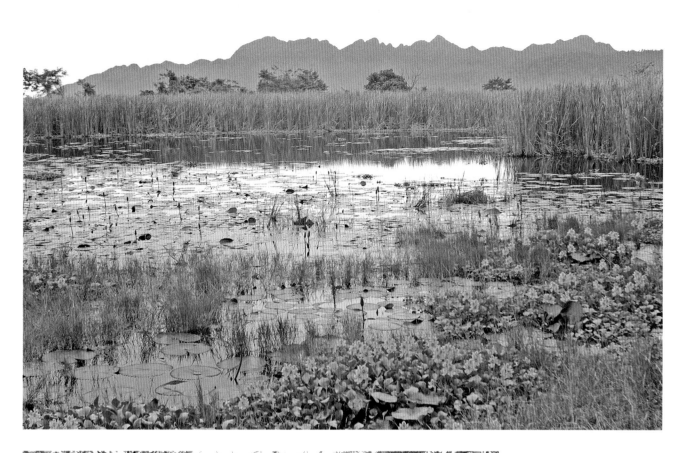

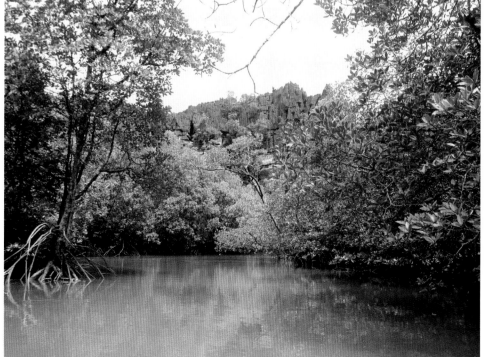

Above: Wetlands are varied ecosystems with reed-lined waters providing a valuable habitat for many resident and migratory bird species.

Left: Mangroves feature special vertical roots or pneumatophores that assist in supplying oxygen to those roots submerged in the mud.

Opposite: Rainforest still blankets many parts of Langkawi and jungle treks with experienced nature guides are available.

Karst Topography

This is typical of limestone areas and includes rounded hills, rugged topography, lakes and caves. The limestone formations were created between 380 and 450 million years ago on a bed of warm, clear sea. Limestone contains fossils and skeletons of ancient marine animals, such as crustaceans and corals. Some limestone has been metamorphosed into marble.

Langkawi has several limestone caves (known as *gua* in Bahasa Malaysia) with the most accessible being Pasir Dagang, Kelawar and Cerita. These caves have formed from millions of years of water eroding through the limestone and, due to Langkawi's abundant rainfall, erosion is ongoing. Some of the caves are home to swiftlets and bats. Swiftlet nests are highly prized in Chinese cuisine as the main ingredient in bird's nest soup.

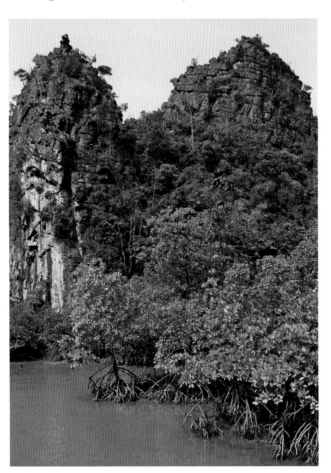

Of the lakes, the Lake of the Pregnant Maiden is the most accessible. This is the island's largest lake and is suspended above the adjoining Andaman Sea. It measures 1 km (two-thirds of a mile) by 0.5 km (a third of a mile) and was formed millions of years ago when the roofs of underground limestone caverns collapsed.

The plants that grow on a substratum of limestone rock are floristically significant as they are home to 13% of Malaysia's ferns and flowering plants (only 0.3% of the land supports such habitats). A thin layer of soil forms on limestone and mostly plants that can survive in nutrient-poor conditions grow here. Microclimates within the forests are common and cycads, orchids, some palms and flowers, such as *Chirita viola*, survive in this environment. Limestone is also mined for cement manufacturing; there is a large plant in the north near the Craft Complex.

White Meranti-Gerutu Forest

Some Langkawi rainforest is classified as semi-evergreen tropical rainforest as the dry season has a pronounced effect on this vegetation with some trees actually shedding their leaves as deciduous trees do in temperate locations. Known as White Meranti-Gerutu forest, a proportion of the leaves on trees in these forests turn yellow and fall from December to March.

Left: Karst topography typically forms on limestone rock. The term is German in origin and refers to the site in Slovenia where the phenomenon was first studied. Parts of Langkawi feature weathered rocks fringed by mangroves.

Opposite top: Boat excursions into Langkawi's mangrove-lined coast are good for bird-watching.

Opposite below: Colourful lilies grow amongst reeds in the wetlands in front of Bon Ton Resort.

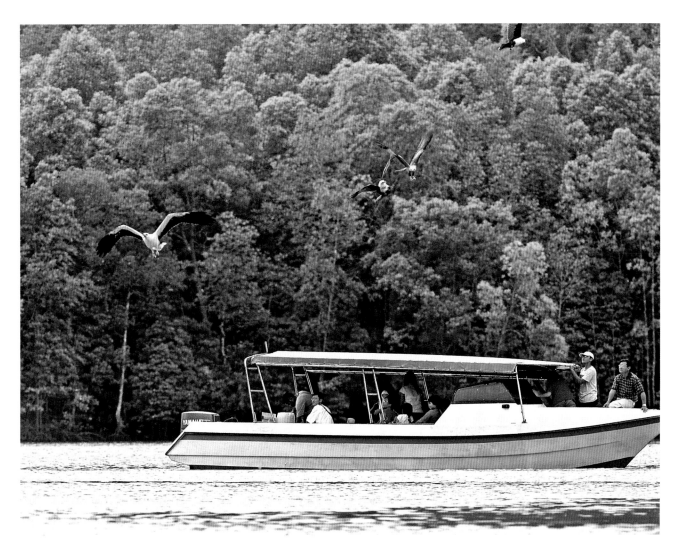

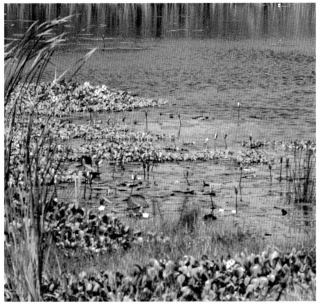

Coastal Waters

The waters surrounding Langkawi have been harvested by local fishing folk for centuries. They are also home to marine animals including otters, reptiles, amphibians, Indo Pacific Hump-backed Dolphins and Finless Porpoises plus the occasional sighting of Bryde's Whales and Whale Sharks. Run-off and sedimentation affect the water quality and few coral reefs survive around the main island. The best water visibility and coral growth is to be found around Payar Island Marine Park, a one-hour boat journey to the south of Langkawi. Each day, boats head to the park and to a pontoon over the coral that enables snorkelling and diving in reasonable conditions.

Rock of Ages

Parts of Langkawi were designated a UNESCO World Geopark in 2007 due to the island's fascinating geology. Nearly 100 geopark sites ensure that Langkawi's geology and the resultant unique vegetation is protected.

Langkawi's sedimentary rocks are considered Southeast Asia's oldest and date back some 550 million years. The sediments for these rocks were deposited in seas, lakes and rivers. Tectonic forces came into play 220 million years ago and granitic igneous bodies breached and forced their way through the sedimentary layers. Limestone is a sedimentary landform that includes layers of sandstone rock of which Mount Machincang is an example. The heat and pressure from the tectonic forces also metamorphosed some sedimentary rocks. Weathering of all the rock formations has been continuous for 220 million years.

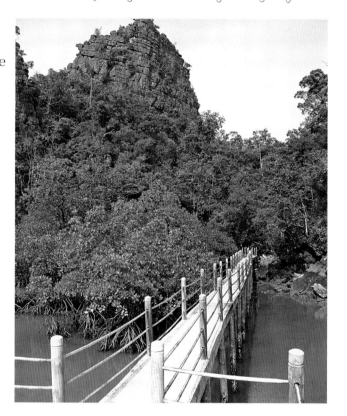

Right: Steep limestone cliffs are some of the most obvious features of the Kilim Karst Geoforest Park and fossils are common within these rocks.

Opposite below: Sedimentary sandstone outcrops can be seen at the Seven Wells Waterfall (Telaga Tujuh) at the base of Mount Machincang.

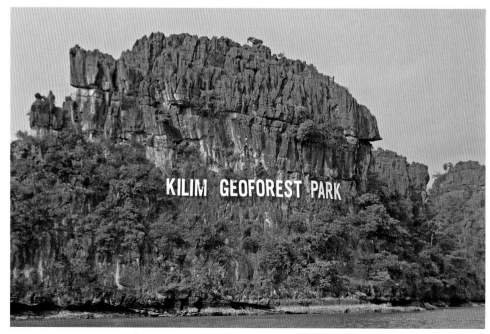

KILIM GEOFOREST PARK

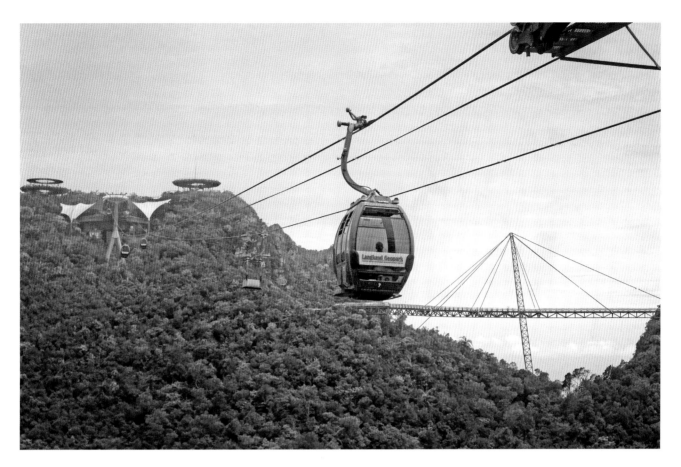

Geopark Areas

Three main areas are identified in the Langkawi Geopark: Machincang Cambrian Geoforest Park, Dayang Bunting Marble Geoforest Park (better known as the Island of the Pregnant Maiden Lake) and Kilim Karst Geoforest Park. Some areas where geological formations are evident include Seven Wells (Telaga Tujuh) and Mount Raya.

Volcanic Formations

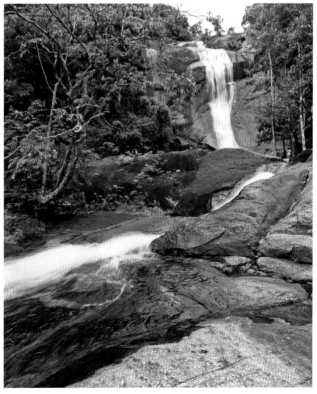

Langkawi's highest peak, Mount Raya at 880 m (2,887 ft) is a granite batholith formed some 230 million years ago way below the Earth's surface. Granite is a large-grained igneous rock formed from magma deep within the Earth's core. Subsequent plate tectonics have exposed the rock to the surface and erosional forces.

Unique Plants

Malaysia is one of the world's great tropical rainforest biomes and home to 40,000 vascular plant species. These are mostly flowering plants and the rest are ferns and conifers (by comparison, Europe has 11,500 vascular plants). A seemingly endless number of fungi, algae, liverworts and mosses is also supported in Malaysia. Langkawi has a fascinating portion of this diversity with plants from ancient cycads to forest trees.

Below: Coconut palms line most of Langkawi's popular beaches like Cenang Beach (pictured) but in places like Tanjung Rhu, pine-like casuarina trees dominate.

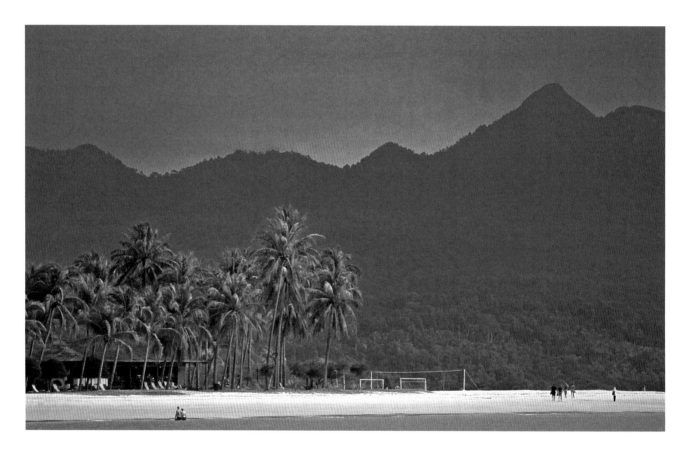

Langkawi's beaches are lined with casuarina trees and coconut palms while muddy estuaries support mangroves. Limestone rock butts up against the sea and specialized vegetation grows in crevices and the thin soil layer here. Forests thrive in the tropical conditions of the centre of the island while the cooler conditions on Mount Raya support montane plants, especially ferns.

Coconuts palms have many uses including protecting coastlines, as building materials and as a source of food. Coconuts provide a quenching drink and are an essential ingredient in Malaysian cuisine. The large woody fruits float enabling them to germinate in distant parts of the ocean. It is not uncommon to see coconut fruits washed up onto many of the beaches of Langkawi.

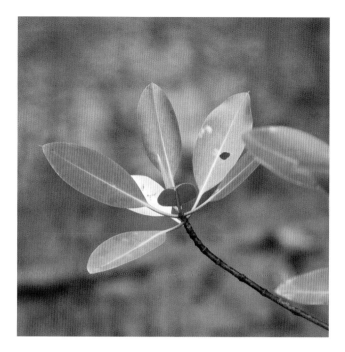

The mangrove is another valuable plant covering an estimated 3,240 ha (8,000 acres) of Langkawi's coastline. These plants are adapted to the high salinity of seawater and serve many ecological functions, such as coastline protection and as a habitat for marine and terrestrial fauna. Trees have pneumatophores ('breathing roots') to obtain oxygen and seeds that germinate while still on the tree.

These seedlings are spear-shaped and designed to pierce the soft mud below the tree before becoming anchored. Most have extensive prop roots that rise above the water and use reverse osmosis to obtain freshwater from saltwater. Sediments are trapped in these roots and provide nutrients for marine organisms, such as barnacles, mangrove crabs, mud lobsters, oysters and shrimps.

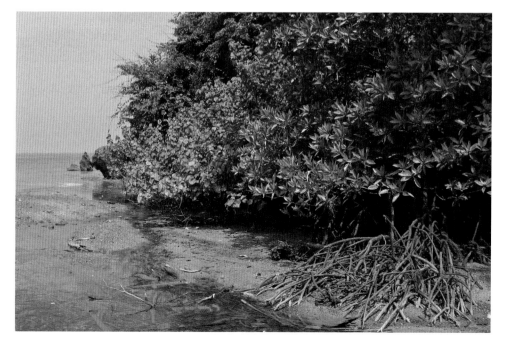

Above left: The leaves of mangrove plants excrete salt to regulate the excesses of its salt-rich environment.

Above right: Mangrove seeds are buoyant and float vertically making them ideal for dispersal.

Left: Mangrove roots can survive higher temperatures and the drying out caused when they become exposed during the inter-tidal period.

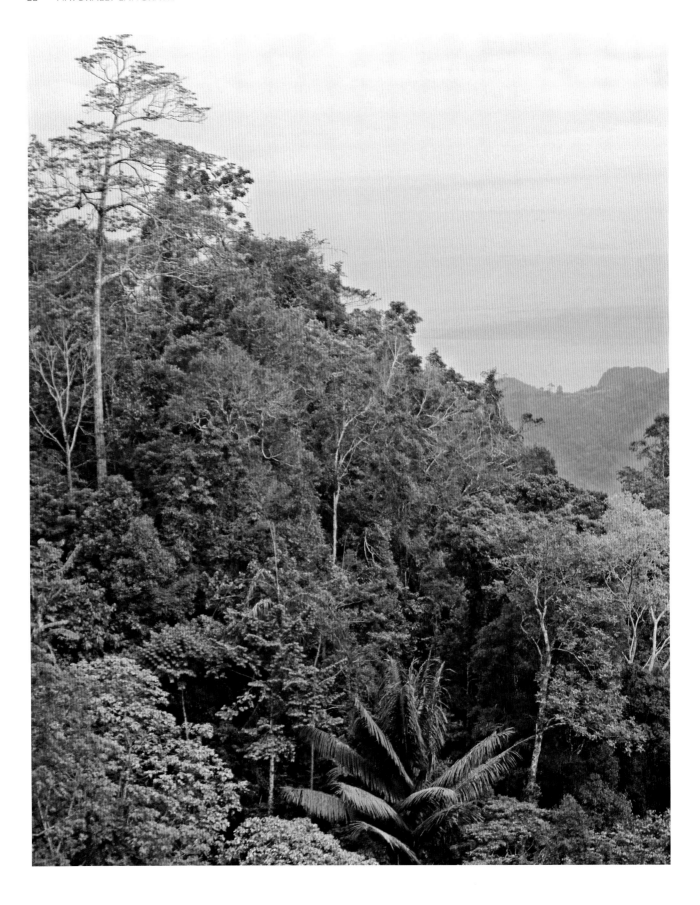

Cycads are tree species with stunted, crooked trunks that are crowned with large, feathery fronds. Often referred to as living fossils, cycads first appeared 300 million years ago and once ruled the plant kingdom. They are gymnosperms and are reminiscent of palms in their growth habit. There are male and female parts on separate structures on different plants. Cycads grow slowly and those that aren't illegally removed for landscaping may be centuries old.

Langkawi's rainforests are home to many species from large trees to microscopic lichen. Giant trees, such as figs and dipterocarps, grow alongside ginger plants, orchids, vines, palms and ferns. Fruit trees such as durian and rambutan grow throughout Langkawi.

Some 650 species of ferns grow in Malaysia and many survive in Langkawi's forests. These non-flowering plants don't produce fruits or seeds but propagate by tiny dust-like spores on the underside of their leaves. Many like the Bird's Nest Fern are epiphytic, attaching themselves to tree trunks and branches. Others grow on the rainforest floor while tree ferns thrive on Mount Raya often with trunks of several metres in height.

Palms are most diverse in the lowland forests, of these rattan is an economically important palm used to make furniture, baskets and fish traps. This thorny, vine-like palm is a good climber as are various lianas found in the rainforest. Fan and feathered palms have a variety of fascinating leaf forms.

Langkawi's lush tropical climate is perfect for growing a wealth of plants both local and introduced. All the island's major resorts feature extensive landscaping with plants such as palms, frangipani, bougainvillea, hibiscus, lilies and lotus being used.

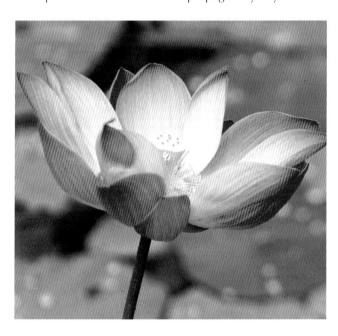

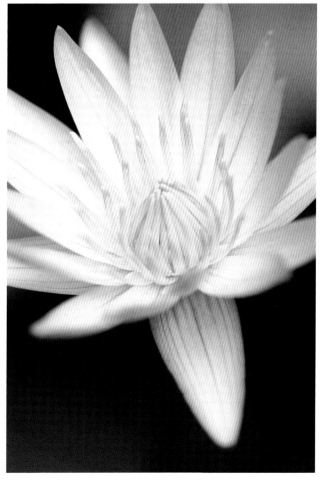

Opposite: Much of the Langkawi interior remains covered in lush tropical rainforest. The forests of Mount Raya (pictured) are easily accessible from the road that leads to the summit.

This page: Flowers such as the lotus (left) and lily (right) are best seen in the island's wetlands.

Unique Animals

A variety of wildlife exists on the Langkawi archipelago, including three primates – the Dusky-leaf Monkey, the Long-tailed Macaque and the Slow Loris. A possible fourth, The Flying Lemur (Colugo), is awaiting final confirmation as a primate. The world's smallest deer, the Mouse Deer, as well as Civet Cats, Flying Foxes, otters, Pangolins (ant eaters) and Giant Squirrels are some of the other animals found.

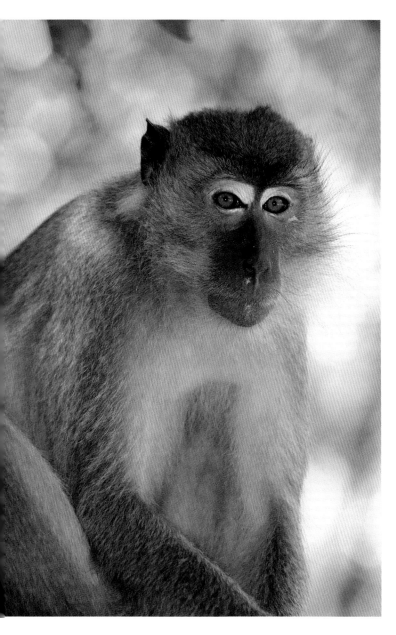

The most commonly seen animals are monkeys especially Long-tailed Macaques (also known as Crab-eating Macaques, although fruits and seeds constitute 90% of their diet). The tails are as long as their bodies. The monkeys are found in groups of 15 to 30 and, being accustomed to humans, they can be a pest scavenging on scraps and taking food despite efforts to discourage them. Groups may be seen in the forests of Burau Bay.

Dusky-leaf Monkeys are less commonly seen and avoid contact with humans. They are grey with white patches around their eyes (hence their alternate name of Spectacled Langur). The young are orange and family groups of 7 to 15 tend to be well hidden in the canopy.

Langkawi is home to the Flying Lemur, considered by some scientists to be the animal most closely related to primates. Interestingly, it is neither a lemur nor does it fly but rather glides from tall trees to those lower in the forest. A membrane connecting the limbs enables this tree-dwelling mammal to glide some 70 m (230 ft). It is a nocturnal herbivore whose young cling to their mother's underside for six months before fending for themselves. They are best seen in the evening in the forests around Datai Bay and Burau Bay.

Along the coasts the Smooth-coated Otter and Oriental Small-clawed Otter may be seen swimming in the sea, scurrying across beaches or hunting in the wetlands. Both are carnivores that feed in the sea and on land and both are listed as vulnerable due to habitat destruction.

Apart from monkeys, animals are rarely seen in the rainforest as the vegetation is dense and the animals well camouflaged. Smaller organisms, such as insects, spiders and butterflies, are most likely to be encountered in Langkawi's forests.

Lizards and snakes also inhabit the mangroves and the waters surrounding Langkawi. Oriental Butterfly Lizards are one of the more unusual species and can be seen darting through open, sandy areas adjoining the coastline. They have a spotted back and striated orange and dark brown underside but move quickly making them difficult to see.

Large Monitor Lizards are often seen but are also fast movers when disturbed. These lizards are native to Southern Asia and Australia and one of the most commonly found reptiles. Males may grow up to 2 m (6½ ft) and weight up to 19.5 kg (110 lb) making them the world's second heaviest lizard after the Komodo Dragon. All are excellent swimmers and very agile on land.

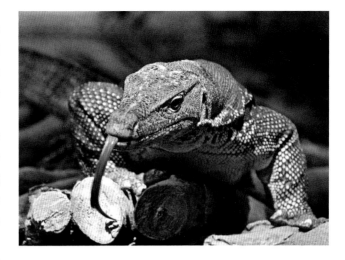

Butterflies are important for pollinating flowers and half of Malaysia's 1,000 species of butterflies may be found on Langkawi. These include the Tree Nymph, Egg Butterfly, Red Helen, Chocolate Tiger and Lacewing. Some 4,000 to 5,000 moths have been recorded in Malaysia including the Atlas Moth, the world's largest.

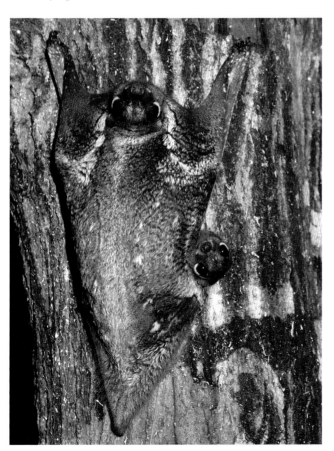

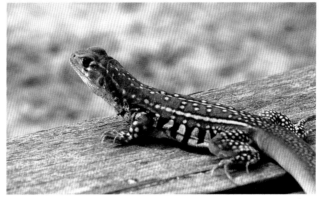

Left: Flying Lemurs (Colugos) are nocturnal mammals that may be spotted during the day resting high up on tree trunks.

Opposite: Long-tailed Macaques are commonly seen congregating around the main tourist sites.

Above: Oriental Butterfly Lizards are most likely to be seen in the grassy areas adjoining beaches, such as those at Burau Bay.

Top: Rustling leaves in the undergrowth generally indicates the presence of a Monitor Lizard.

Langkawi's birdlife is of special interest to ornithologists, birdwatchers and nature guides on the island. Some 200 species have been recorded with the Brown-winged Kingfisher and Red-wattled Lapwing being easier to find here than anywhere else in Malaysia. The forests are home to the Great Hornbill, Great Slaty Woodpecker, ten pigeon species and six species of sunbird. Birds of prey, such as the Brahminy Kite (the island's 'mascot'), Mountain Hawk Eagle and White-bellied Sea Eagle, and waders, such as egrets, are common. Habitats vary from rainforest, mudflats, mangroves, *padi* fields, reed fields, plantations and forests to open areas. Some of the best birdwatching sites are Mount Raya, Mount Machincang and the mangrove forests and *padi* fields near Cenang Beach.

The Oriental Pied Hornbill is one of Langkawi's most common birds. It is 65 cm (25½ inches) from head to tail and mostly black but with a white trailing edge to the wings. While these hornbills are usually seen flying above the canopy or feeding on fruit trees, they often pass over the coast. Packs of three to eight are common. Hornbills have an unusual nesting characteristic where the male surrounds the female with a mud enclosure leaving a narrow opening through which it feeds her until the young hatch and are ready for freedom.

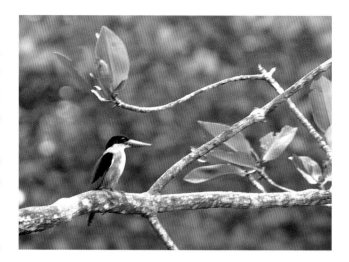

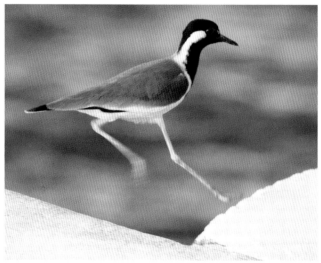

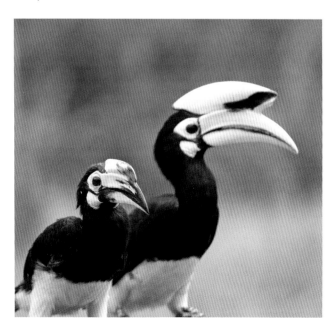

The Red-wattled Lapwing is a resident bird. This large plover is a wader with a red fleshy wattle in front of each eye and can be seen feeding on insects and invertebrates around wetlands. Many migrant species from the north may be seen from November and April.

Left: Mount Raya (Gunung Raya) is one of the best places to see various hornbill species, such as the Oriental Pied Hornbill (pictured).

Above: Langkawi's wetlands and rice fields are perfect for sighting waders and the Red-wattled Lapwing.

Top: The Black-capped Kingfisher is one of eight kingfisher species on Langkawi.

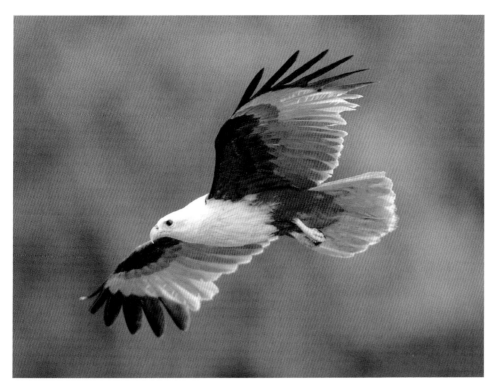

Left: The Brahminy Kite is chestnut and white in colour and one of the most commonly sighted birds of prey especially around wetlands and coastal waters.

Below: Egrets can be seen in the shallows of coastal areas as well as rice fields. They move slowly in the water looking for prey which they jab with their sharp beak.

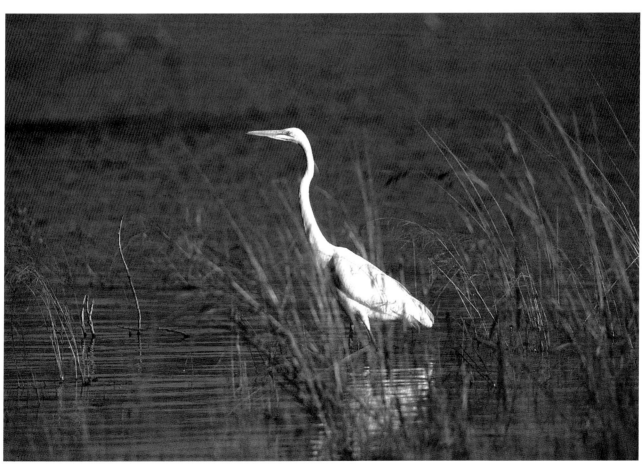

Land and Resources

With only three inhabited islands much of the Langkawi archipelago is undeveloped. Forests grow naturally on most islands and some are protected as forest reserves or within the Langkawi Geopark.

Other land is cultivated or used for tourism, light industry, quarrying and townships. Kuah is the main town and home to most government departments and commercial activities. Few buildings rise above the height of a coconut tree with the tallest being just ten storeys high.

The main agricultural activities are rice farming, rubber plantations and fruit farms. Rice is a dietary staple for most Malaysians. Kedah (of which Langkawi is part) is Malaysia's rice bowl state with most flat parts being verdant green at the beginning of the rice-growing cycle or golden yellow prior to harvesting. The Rice Museum at Cenang Beach on Langkawi Island explains how important rice is to Malaysia.

Rubber was introduced to Malaysia as a cash crop by the British in the late 19th century. It is typically grown in plantations of uniform rows and the latex is collected to produce rubber. Malaysia is the world's third largest producer of natural rubber and there are several plantations on Langkawi especially near Mount Raya. Usually the only activity is early in the morning when the bark is scored and the latex collected.

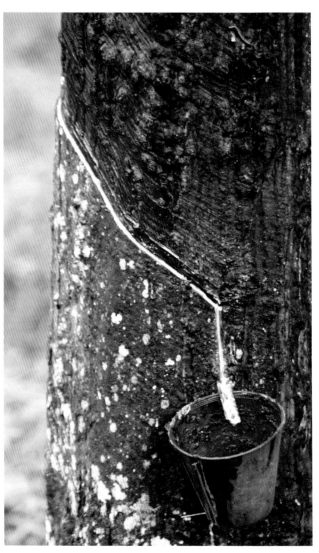

This page: Rubber is important to the Langkawi economy with several large estates (top left) being located mostly on the north-east of the main island. The white latex is collected in small cups for processing (above).

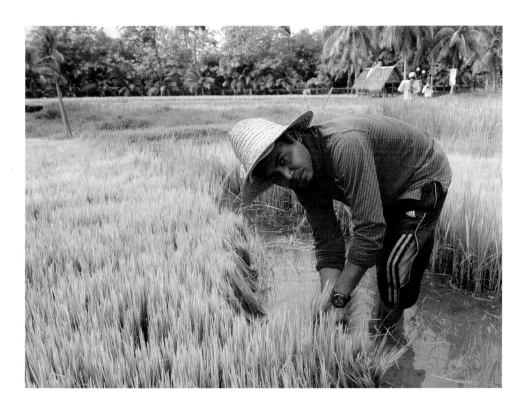

Left: While rice is grown in many parts of the lowlands, the best place to learn more about this important crop is at the Rice Museum ('Laman Padi') near Cenang Beach.

Below left: Some of the seafood consumed on Langkawi is raised and harvested from 'farms' located on former wetlands.

Below: Fleets that fish the Andaman Sea shelter along coastal streams.

Some of the island's mangroves have been cleared to establish commercial prawn farms. Shrimpz Prawn Farm on the south-west tip of the main island is a large commercial operation. Visitors can view the farm and dine in the restaurant indicated by the giant prawn signpost located along Bukit Malut Road near Awana Porto Malai.

The other main industry is cement production with a large factory and port at Teluk Ewa in the north near the Langkawi Craft Complex.

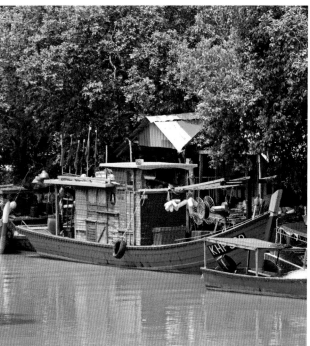

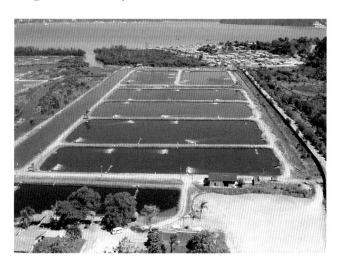

An interesting local industry is the production of *gamat* or the Golden Sea Cucumber. It has been used as a folk remedy for over 500 years. Various treatments and skincare lotions from *gamat* are still produced.

Adventures, Sports and Lifestyle

Langkawi is best known for its natural attractions although its laid-back lifestyle and village life, beachside resorts, indulgent restaurants, soothing spas and low-key nightlife set Langkawi apart from other regional resort islands.

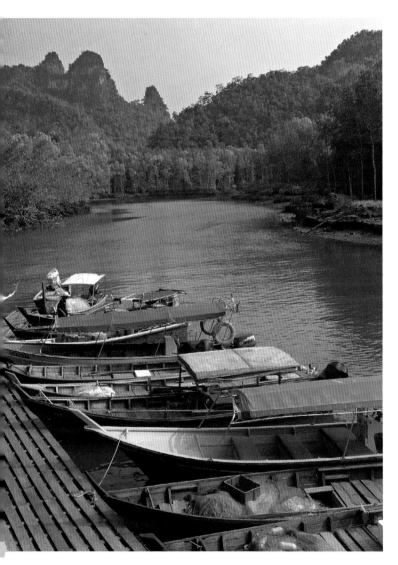

Mangrove tours along rivers such as Air Hangat, Kilim and Kisap are the most popular eco adventures. Organized tours traverse these rivers and the coastal bays providing good opportunities to see the plants and animals, especially birds of prey. Most tours depart from jetties at Kilim and Tanjung Rhu and many include an exploration of the limestone caves.

For more active exploration there are organized jungle treks, the most popular of which are walks through the rainforests near the base of Mount Machincang and to Seven Wells. While Long-tailed Macaques are commonly seen along with insects, butterflies and reptiles, walkers will have to look hard to see other animals. Using the services of one of Langkawi's experienced eco guides for either day or evening walks is recommended.

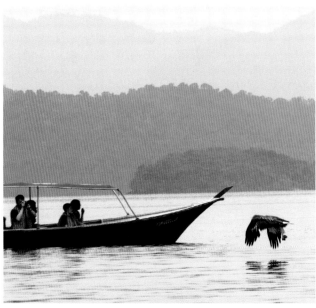

Above: *While there are several departure points for mangrove touring, the main one is the jetty at Kilim River.*

Right: *Eagle watching with responsible tour operators is one of the most popular nature-based activities.*

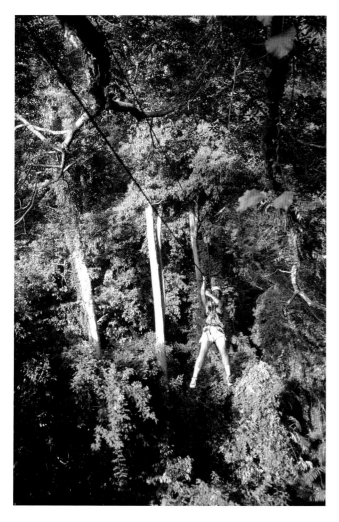

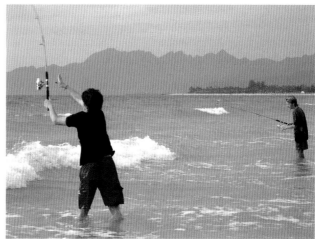

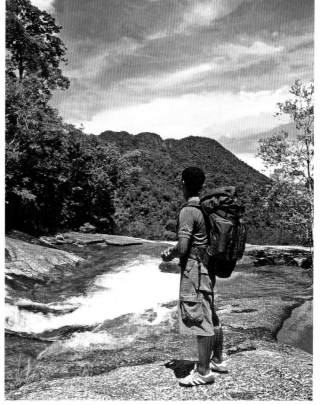

Left: Soaring along zip-lines through the rainforest canopy is an exhilarating activity offered by Langkawi Canopy Adventures.

Below: Some resorts provide fishing gear to enable anglers to fish along the foreshore.

Bottom: Jungle treks to places like Seven Wells (Telaga Tujuh) are best done with guides.

Langkawi Canopy Adventures offers one of the island's most action-packed and thrilling adventures through the rainforest canopy. It involves abseiling, zip-lining and rappelling through the ancient rainforest of Mount Raya. The company also offers a comprehensive range of eco adventures on land and sea.

Other less strenuous recreational activities include fishing, birdwatching, kayaking, caving and cycling. Travelling on the Langkawi Cable Car to the summit of Mount Machincang is an exhilarating ride on one of the world's steepest ascents. The 2-km (1¼-mile) long ride provides views over the island and into southern Thailand.

Themed attractions include the Crocodile Adventureland, Underwater World and Langkawi Wildlife Park (see pages 70 and 71).

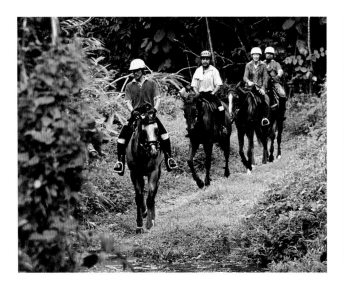

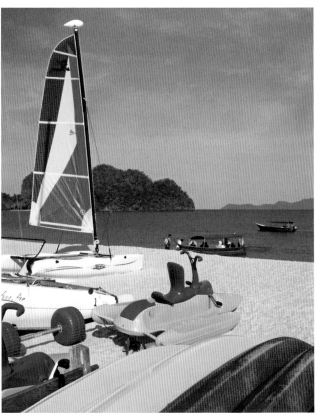

For those keen on sports, there's golf, horse-riding, go-karting and watersports. There are three golf courses on the island – Gunung Raya, Datai Bay and 99 East. The first two are 18-hole courses while 99 East has nine holes but with plans to become a full championship course. 'Island Horses' operates from near Seven Wells offering lessons plus rides along the beach and through the jungle and villages.

Cenang Beach is the favoured location for motorized sports, such as para-sailing and jet skiing, although both are low-key affairs. Jet ski touring is a burgeoning activity. There are four marinas with bareboat chartering possible at the Royal Langkawi Yacht Club. Day and sunset cruises are offered by several boating operators.

Shopping attracts many tourists especially as the island is a duty-free paradise. Prices on many products are therefore cheaper than on the mainland and while many stores have fixed prices, there's no harm in bargaining. Most of the shopping is concentrated in Kuah where there are several large shopping centres especially near the ferry terminal. However, most shops on the island are small, family-operated enterprises. Other places to shop include Underwater World at Pantai Cenang, the airport, Oriental Village and Perdana Quay near Burau Bay and the Craft and Cultural Complex on the far north of the island. While Fridays and Saturdays are holidays on Langkawi most shops remain open. Atma Alam Batik Art Village in Padang Matsirat

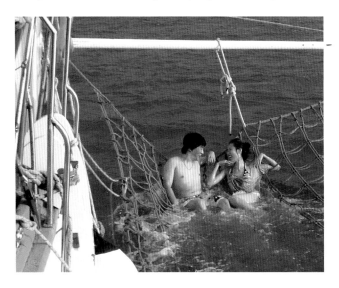

Above: *A boom net offers a 'natural jacuzzi' for those who join yachting cruises.*

Top and top right: *Experienced handlers conduct rides along beaches and through the jungle. Elsewhere most resorts offer watersports.*

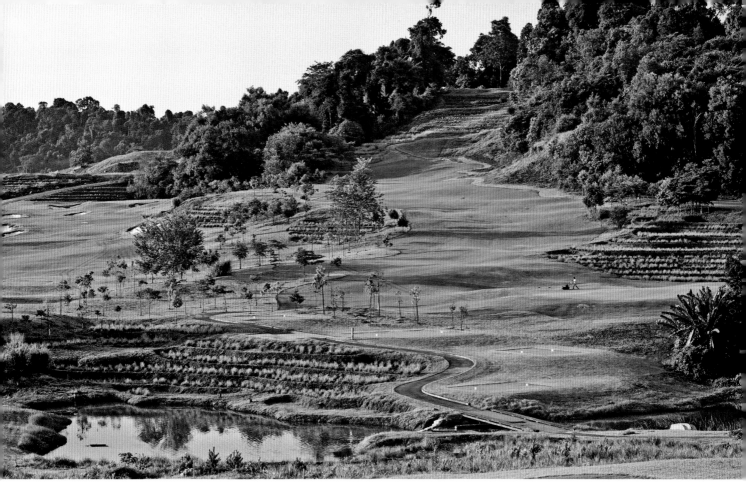

sells Malaysia's famous fabric as well as offering workshops for visitors to design and produce their own *batik*. *Songket*, a beautiful woven silk or cotton with patterned gold and silver thread is also sold.

There are several museums covering diverse topics ranging from rice to crafts and the official gifts presented to a former Malaysian Prime Minister.

Many visitors choose to relax in their resort of choice with the aim of indulging in fine cuisine, imported wines and soothing spa treatments. Most of the international resorts on Langkawi will have just what these visitors are looking for.

Above: Three golf courses including 99 East (pictured) provide challenging forest-lined fairways and tropical greens for golfers of all abilities.

Right: Children especially will enjoy creating a 'batik' masterpiece.

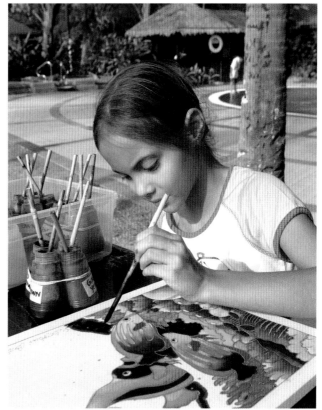

Chapter 2: The South and South-west

Kuah is located on the south-eastern tip of the main island. Legend has it that its name, which means 'gravy' in Bahasa Malaysia, relates to the spot where two giants spilled a pot of curry while fighting.

Below: Ferries operate during daylight hours from the terminal to Kuala Perlis and Kuala Kedah on the mainland and Satun in southern Thailand.

Kuah

While known as Kuah, many refer to it as Kuah Town because it is the only urban, retail and commercial area of any size on Langkawi Island. Just a few decades back, Kuah was a sleepy village with Kuah Jetty being the place where travellers arriving by boat disembarked. Now it is a thriving market town, duty-free shopping paradise and administrative centre for the Langkawi Development Authority (LADA).

Most of the shops are small but there are a few shopping centres, such as Langkawi Fair, Langkawi Mall and Jetty Point Duty Free Complex.

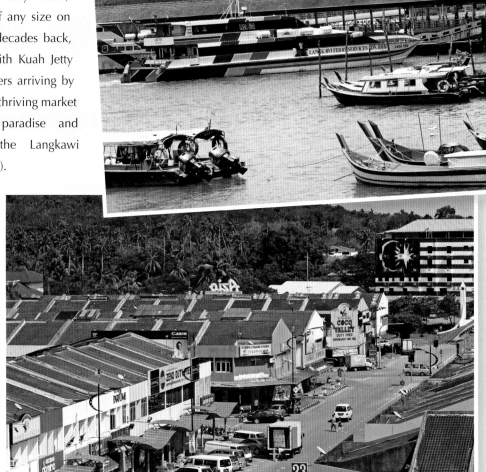

Right: Many visitors love both to explore the streets of Kuah for duty-free bargains and to discover the delicious local food served in the many restaurants and cafés.

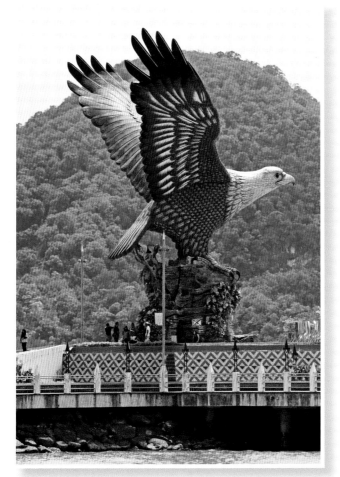

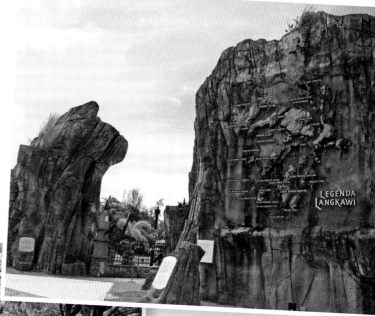

Left: Lagenda Park and Eagle Square (Dataran Lang) are popular with local visitors and tour groups. The 12 m (39.4 ft) high Brahminy Kite at Eagle Square is visible from arriving ferries and is the island's mascot. Legend has it that Langkawi gets its name from the local word for eagle, 'helang'. In old Malay, 'kawi' means reddish brown, so Langkawi refers to a reddish brown eagle which is actually the Brahminy Kite.

Above and left: Lagenda Park has a scenic setting with ponds and landscaped gardens that contain exhibits on the legends and myths of Langkawi.

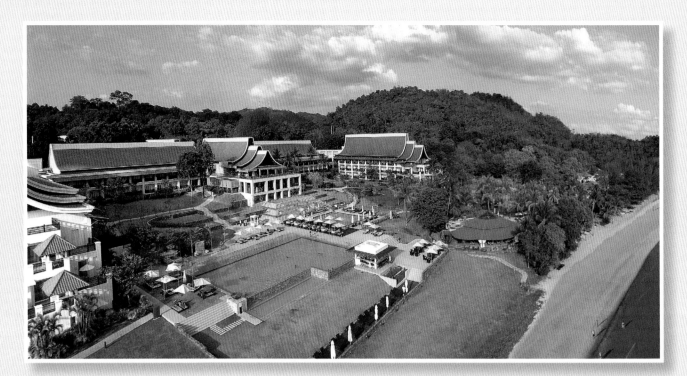

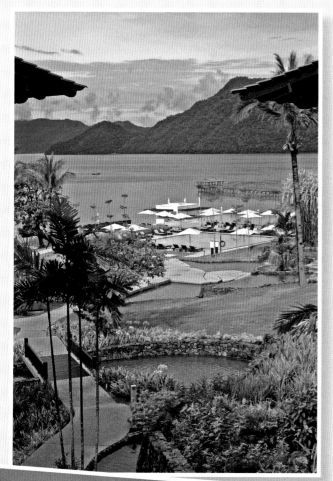

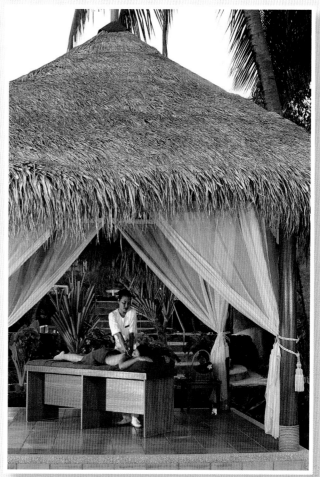

These pages: The Westin Langkawi Resort and Spa offers five-star international accommodation in a tranquil setting beyond Kuah Jetty ferry terminal and the Royal Langkawi Yacht Club. Most of the town's other hotels offer budget to three-star accommodation.

Cenang Beach

After Kuah, Cenang Beach (Pantai Cenang) is the most populous part of the island and the most popular with holidaymakers seeking sand, sun and surf. In the evenings, the cafés, restaurants, bars and shops are busiest but Langkawi nightlife is very sedate compared to most other tourist islands in the region.

Morac Go Kart track lies between Cenang Beach and the airport and provides all the thrills and action on a 1-km (²/₃-mile) long track.

Underwater World, the biggest building on the main strip of Cenang Beach, is one of the largest aquariums in the region housing over 3,000 marine and freshwater organisms.

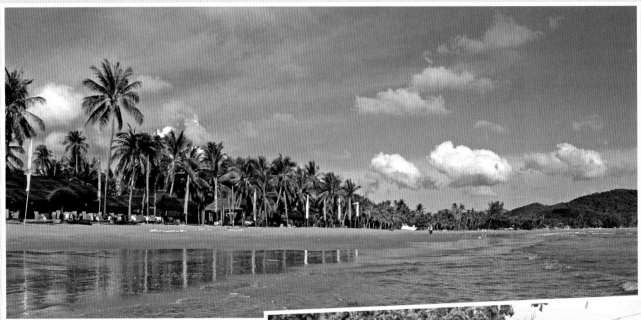

Above: Cenang Beach's restaurants and cafés serve an enticing range of dishes and an international smorgasbord of styles. Seafood dominates as do small locally operated restaurants especially those serving Malay dishes. While a few international fast-food chains are taking up residence, the lively scene is very much local. A handful of iconic bars swing into action later in the evening with a few extending onto the sandy beach.

Right: The main road through the Cenang Beach shopping area is quiet for much of the day but becomes livelier in the evening as visitors return from the beach to seek a meal, a drink or to go shopping.

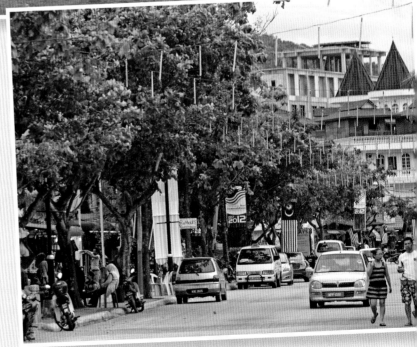

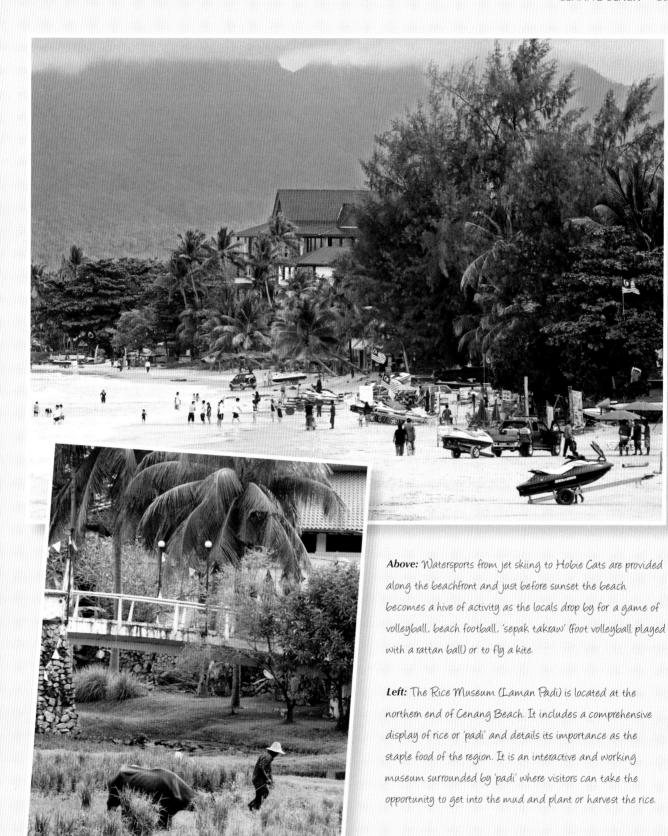

Above: Watersports from jet skiing to Hobie Cats are provided along the beachfront and just before sunset the beach becomes a hive of activity as the locals drop by for a game of volleyball, beach football, 'sepak takraw' (foot volleyball played with a rattan ball) or to fly a kite.

Left: The Rice Museum (Laman Padi) is located at the northern end of Cenang Beach. It includes a comprehensive display of rice or 'padi' and details its importance as the staple food of the region. It is an interactive and working museum surrounded by 'padi' where visitors can take the opportunity to get into the mud and plant or harvest the rice.

These pages: While the Meritus Pelangi Beach Resort and Spa (above right) and Casa Del Mar provide international accommodation with extensive services and facilities, most of the accommodation caters to budget travellers. However, Bon Ton (centre and below right) and Temple Tree (opposite page) Resorts are unique in providing a stately collection of antique houses relocated from all over Peninsular Malaysia and lovingly restored. They provide an architectural journey through colonial Malaysia but with interiors featuring all the creature comforts to cater for discerning, design-oriented travellers. Pools, an acclaimed 'west meets spice' restaurant with a serene setting overlooking a wetland, provides guests with a memorable experience.

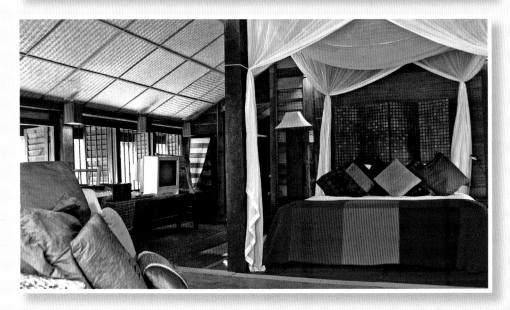

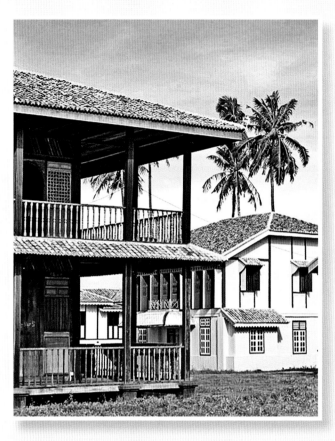

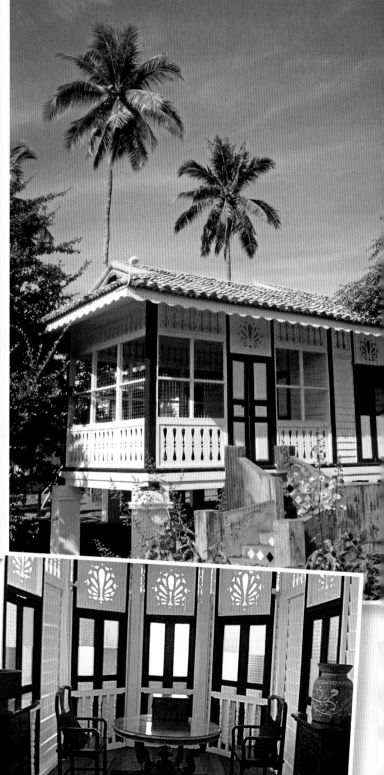

Tengah Beach

Despite being separated by a small headlan... ...ah Beach faces west and ...moons are especially magical ... and offshore islands. The
(Pantai Tengah) is basically a continuation o... ...oping shoreline that is perfect
although less developed, less commercial an... ...shing.

South of Airport

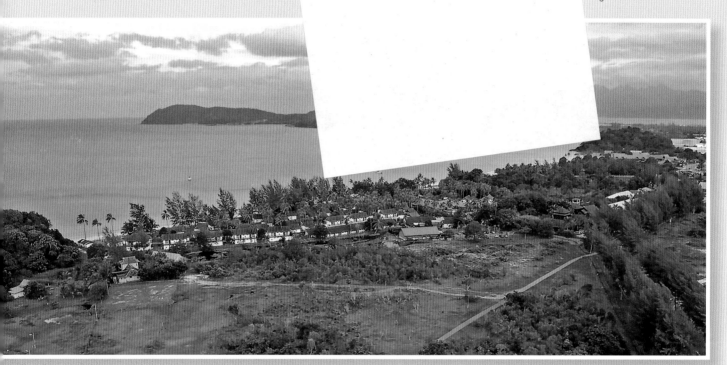

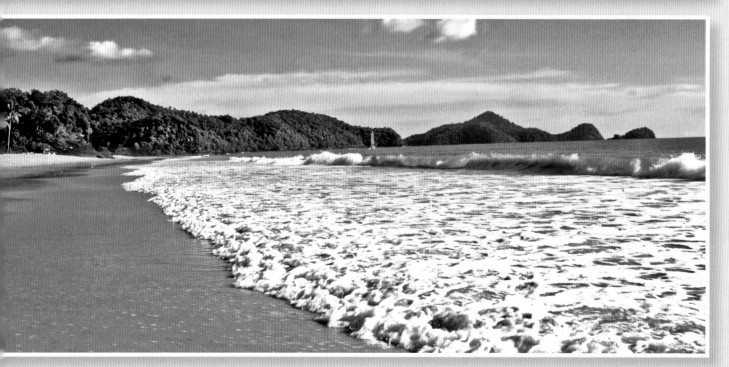

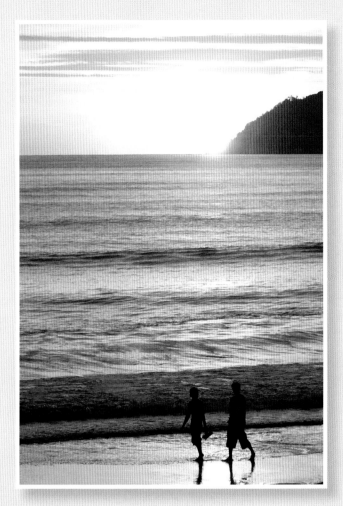

Below and bottom: Tengah Beach is popular for watersports, especially para-sailing later in the afternoon. There are several operators who take adventurous visitors high into the air suspended by a parachute pulled by a speedboat.

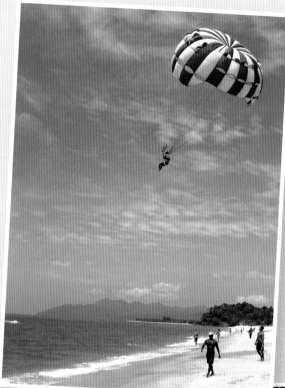

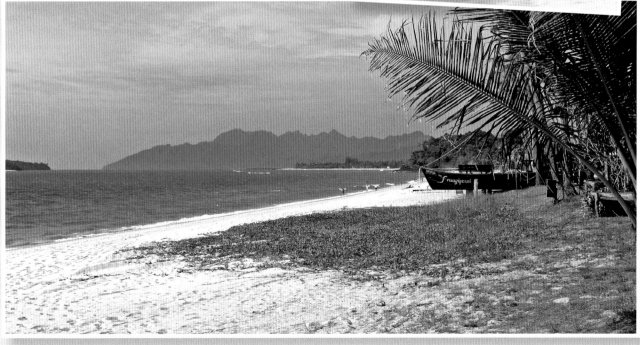

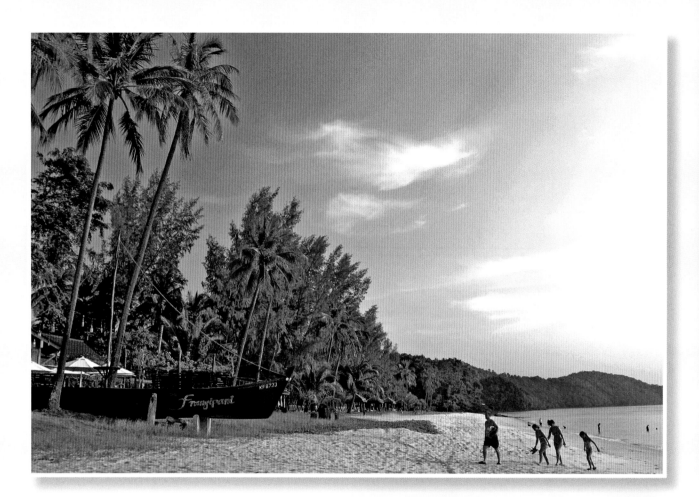

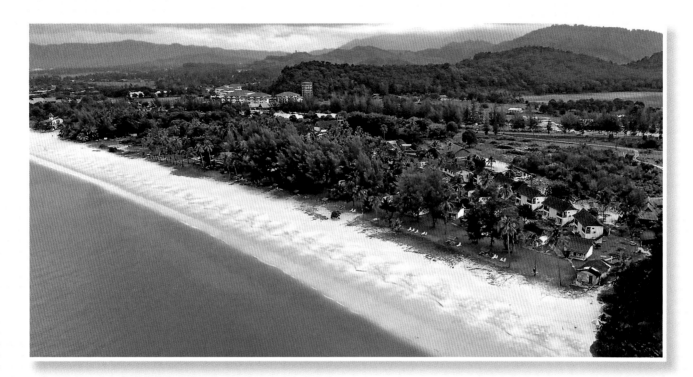

Above: Development along Tengah Beach is restricted to the coastline with rice fields and forests extending into the hinterland.

Opposite page: Tengah Beach is home to several mid-scale resorts with the Frangipani Langkawi Resort and Spa (pictured) considered to be one of Asia's most environmentally friendly. In addition to providing its guests with deluxe beachside accommodation, the management have introduced many environmental practices including composting, growing organic vegetables, recycling and environmental education activities for guests, government officials and other hotels in the region. One of the resort's main green initiatives is to use a biological wastewater system that operates without the use of energy.

Right: Other hotels and resorts in the area include Fave Hotel, Aseania, Holiday Villa and The Lanai. The road from Cenang Beach to Awana Porto Malai is lined with restaurants, a few bars, spas, shops and several small budget hotels.

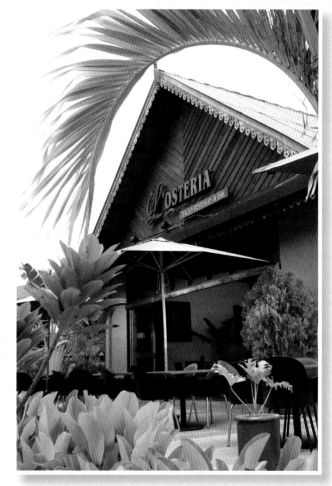

Padang Matsirat

Close to the airport is Padang [M...]
settlements on the island. Its main [...]
restaurants and food stalls. The area [...]
resorts, such as Four Points by S[...]
Lagoon, are located. Hotel Helang [...]

One of Langkawi's legends is th[e ...]
Rice (Beras Terbakar) where blacken[ed ...]
appear on the soil surface. These are [...]
of grains burned by the Siamese duri[ng ...]
The actual site is small and of little a[...]
traditional house adjoins the site. C[...]
also available in the market situated in the car park for the
Field of Burnt Rice.

Right: Padang Matsirat is worth visiting especially around lunchtime
to appreciate the finer qualities of the very popular lunch called 'nasi
campur' or mixed rice. There are several roadside diners that
specialize in rice served with vegetable and meat dishes. One or two
offer a range of more than 20 types of curries and fried or grilled
meats, with fresh vegetables and cut chilli ('chilli padi') on the side.

North of Airport

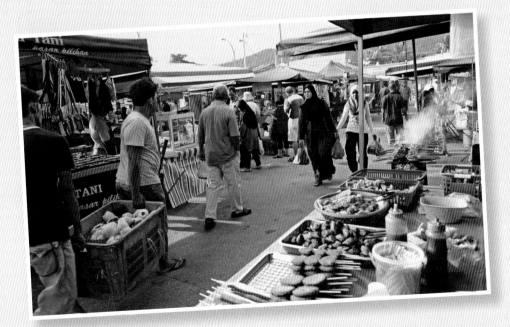

Left and opposite: The island's
biggest and most popular night
market ('pasar malam') is held
every Sunday from late afternoon
to late evening. Cooked food and
fresh ingredients are the most
popular items sold. Visitors will
love the colour, excitement and
the range of exotic dishes offered,
such as satay, spicy chicken
('ayam percik') and cakes ('kuih
peneram').

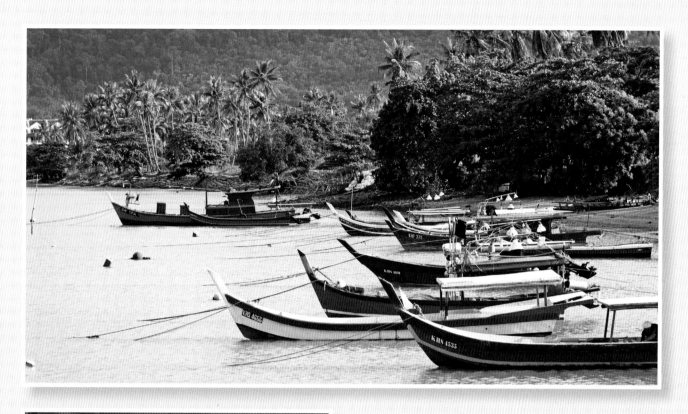

Above: The fishing fleets moored at Kuala Teriang and near the Langkawi Lagoon Resort look colourful against a backdrop of palms and casuarina trees.

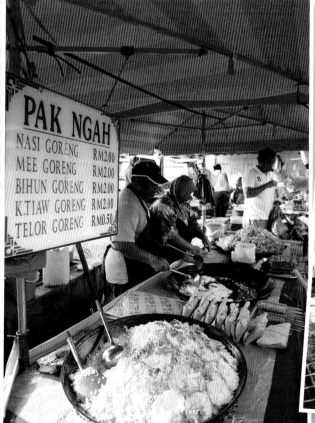

PAK NGAH

NASI GORENG	R.M 2.00
MEE GORENG	R.M 2.00
BIHUN GORENG	R.M 2.00
K.TIAW GORENG	R.M 2.00
TELOR GORENG	R.M 0.50

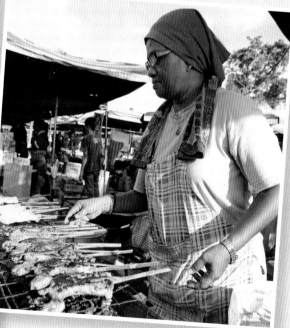

Awana Porto Malai

The far south-western point of the main island is home to a resort, marina and cruise ship wharf. The Mediterranean-inspired Awana Porto Malai Langkawi is the only substantial resort here although there are some smaller ones nearby. A colourful exterior and broad wooden boardwalk greet visitors many of whom arrive via the cruise line terminal.

These pages: This part of Langkawi supports a small marina that is the base for many boating and sailing charter companies, such as Crystal Yachts and Tropical Charter, that offer trips to the several smaller offshore islands. These include eco tours, island hopping, fishing trips and sunset cruises.

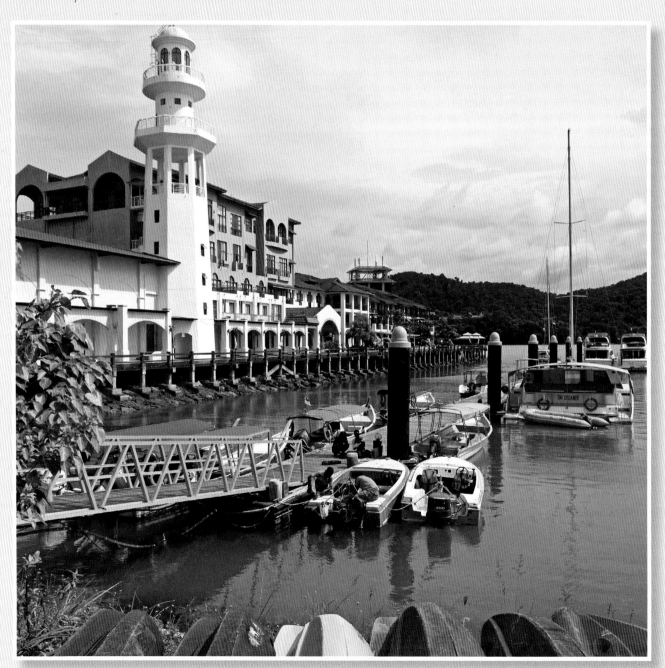

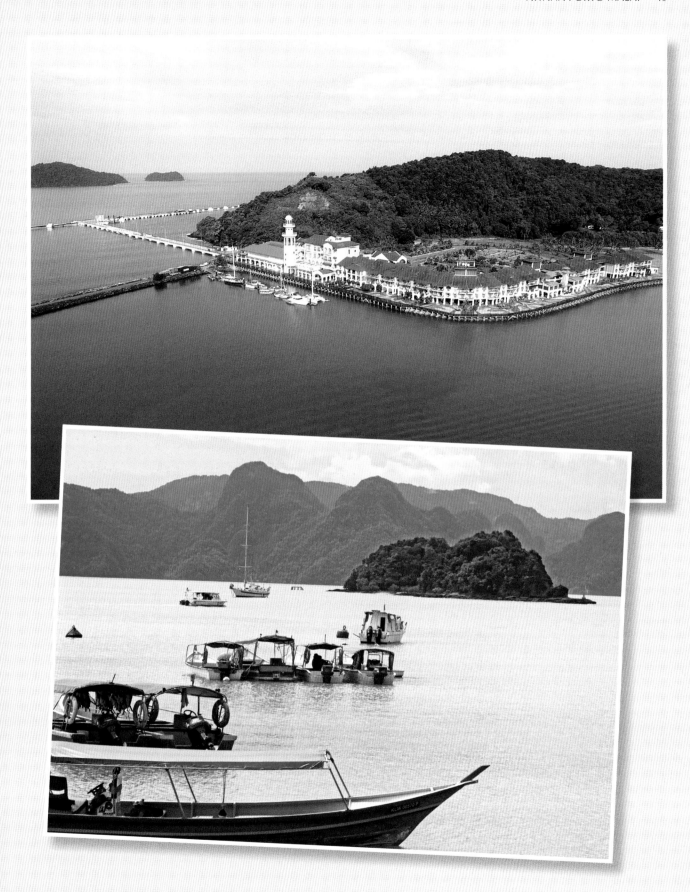

Burau Bay

Burau Bay (Teluk Burau) lies at
Machincang on the far western part
main road from the airport ends here
road heads north from Perdana Quay
Kok) for those circumnavigating the is

Where we're staying

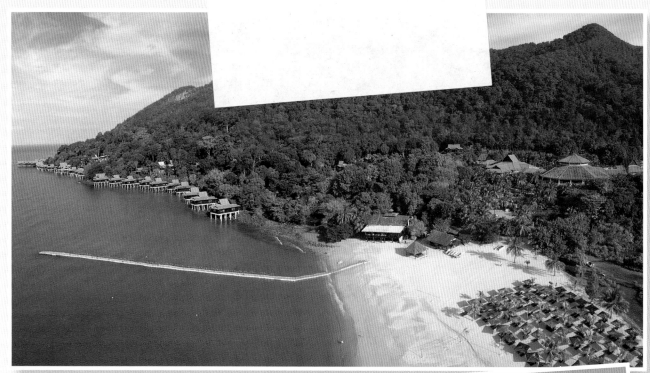

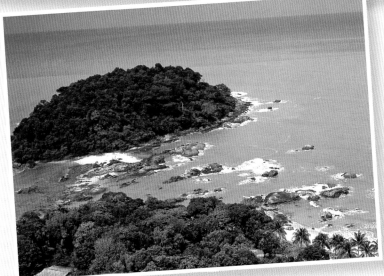

This page: There are several resorts located near Burai Bay (right). Starting at the east end and moving westward, these are the Sheraton Langkawi Beach Resort, The Danna Langkawi, Berjaya Langkawi Beach Resort and Spa, and the Geopark Hotel in the Oriental Village. The Berjaya property includes private chalets over the Andaman Sea (above), the Danna overlooks Kok Beach and Telaga Harbour Marina while the Sheraton's deluxe accommodation features natural timber with a rustic design. The mangroves near the Berjaya property are especially good for catching sight of the Brown-winged Kingfisher. Playful otters are often seen here too.

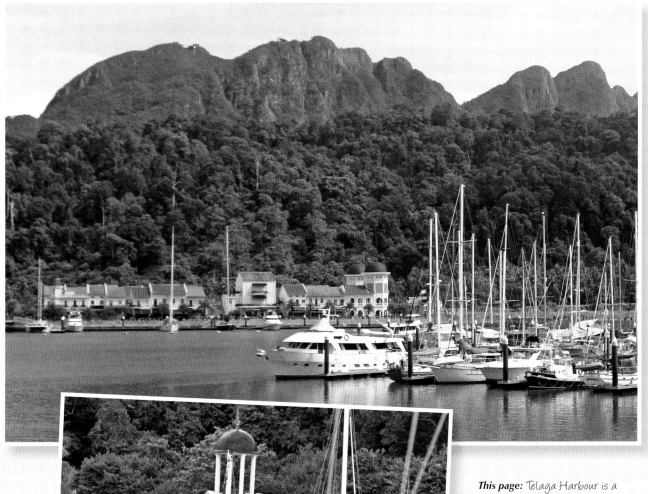

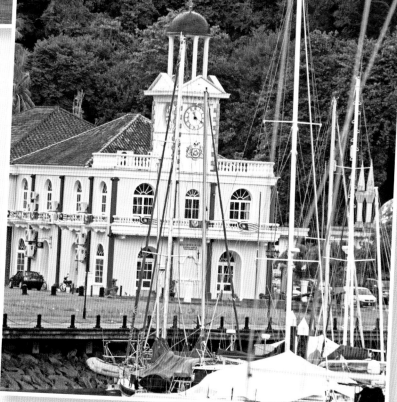

This page: *Telaga Harbour is a marina that provides shelter to yachts from around the globe. Ferries to Koh Lipe in Thailand's Tarutao National Marine Park depart from Telaga Terminal from November to May. Perdana Quay overlooking the marina at Telaga Harbour has a seaside village atmosphere with cafés, restaurants, bars, shops and a spa.*

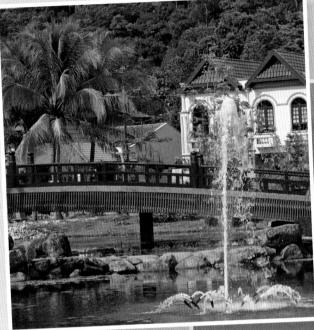

Left: Oriental Village with its shops, restaurants and inn is the departure point for the cable car.

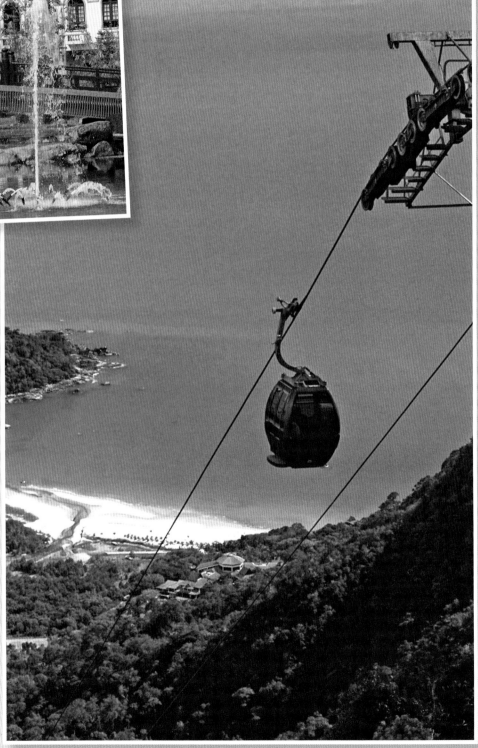

Right: Langkawi Cable Car rises from Oriental Village to the summit of Mount Machincang at 713 m (2,239 ft). This 2-km (1¼-mile) journey is one of the world's steepest and provides spectacular views over the rainforest canopy and the beaches in the distance. There are two points to alight from the cable car with the top station offering excellent views over the island and off in the distance to Tarutao National Marine Park in southern Thailand. Other walks on Mount Machincang are accessible from the cable car with the preferred method being to ride the cable car to the summit, then walk down.

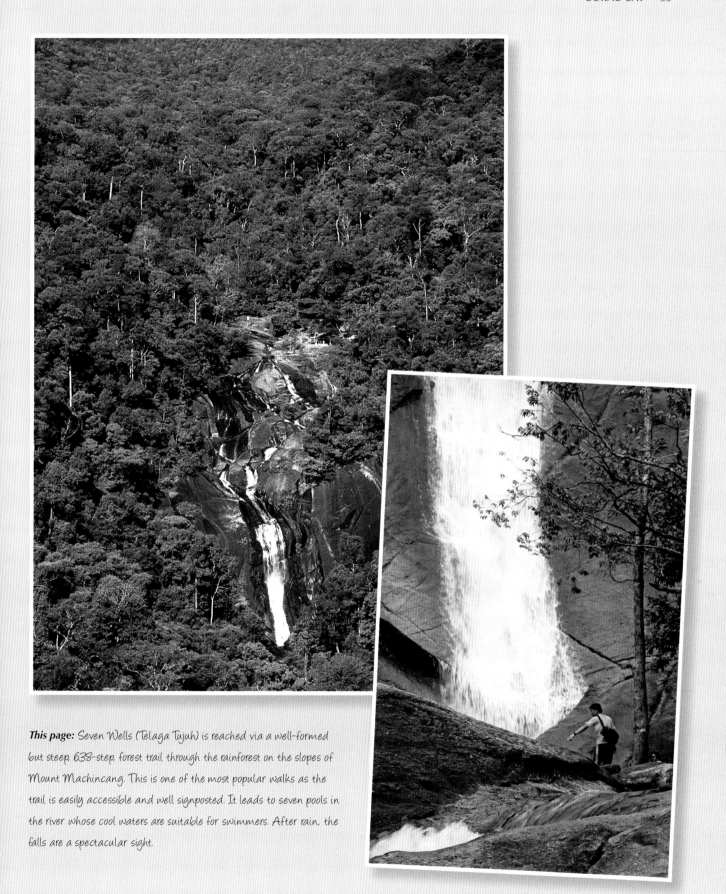

This page: Seven Wells (Telaga Tujuh) is reached via a well-formed but steep, 638-step, forest trail through the rainforest on the slopes of Mount Machincang. This is one of the most popular walks as the trail is easily accessible and well signposted. It leads to seven pools in the river whose cool waters are suitable for swimmers. After rain, the falls are a spectacular sight.

Chapter 3: The North

The far north-west of the main island is the exclusive domain of two luxurious resorts surrounded by untouched rainforest leading up to the steep slopes of the western side of Mount Machincang.

Datai Bay

Datai Bay is Langkawi's most scenic beach, where ancient rainforests overhang the golden sands of this long, near-deserted bay. The forests at sunset offer the best opportunity to see the Flying Lemur (Colugo) gliding among the trees.

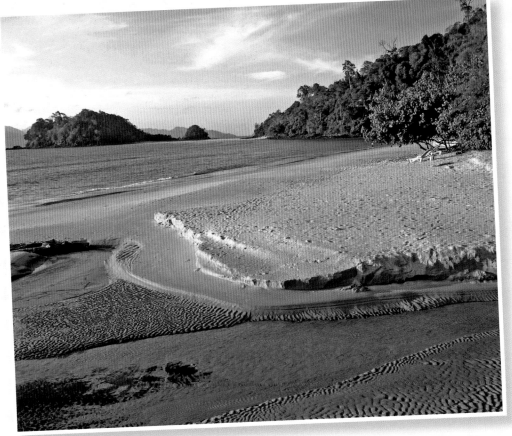

Above: On the far north of the island Datai Bay (Teluk Datai) is blanketed in virgin forests that are the home of two exclusive resorts. The Datai and The Andaman are located within the rainforest but just minutes from the tree-lined beachfront.

Left: Part of the promontory here has been eroded to form residual islands or sea stacks. Subsequent erosional forces have carved out sea caves in the ancient sandstone and shales. The distant islands offshore are those of Thailand's Tarutao National Marine Park.

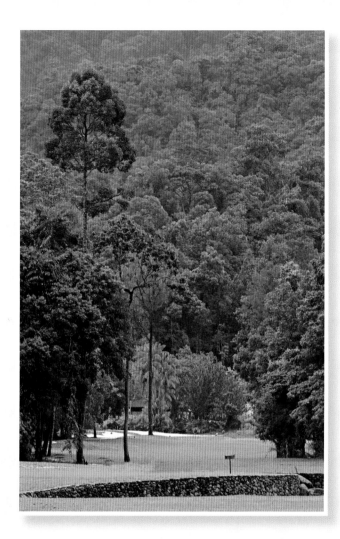

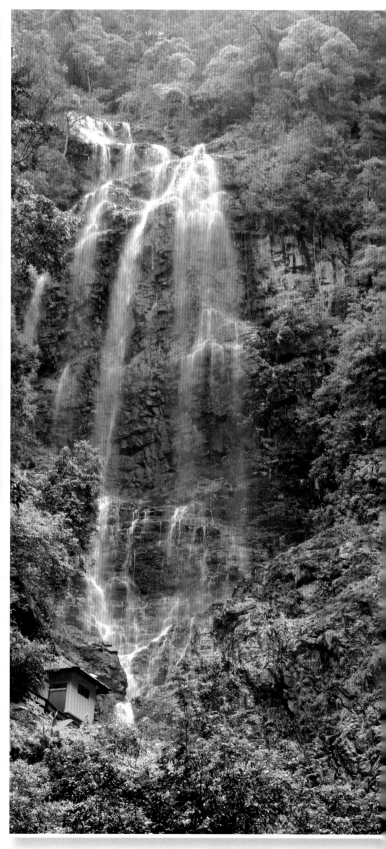

Above: Close to the two resorts, the Golf Club Datai Bay has been masterfully crafted through ancient rainforests by golfing legend Ernie Els. This 18-hole, championship course has been recently redesigned by Els to provide an even more challenging one with narrow, forest-lined fairways.

Right: The road to Datai Bay passes several places of interest including Crocodile Adventureland Langkawi (see page 70), Pasir Tengkorak Beach and Temurun Waterfall. Pasir Tengkorak Beach is an accessible beach facing the islands of southern Thailand. There are basic facilities here and a pleasant, shaded beach for swimmers. At 35 m (100 ft), Temurun Waterfall is Langkawi's tallest and most spectacular, especially after rain. The river has been dammed below the falls creating pools that have made the area popular with the locals for picnics and bathing.

Tanjung Rhu

Tanjung Rhu means 'Cape of Casuarinas' after the trees that line this long beach. These pine-like trees grow well in the sandy, saline soils. They are native to the area and are characterized by many green, branch-like twigs which the wind whistles through. The beach is a peaceful part of the island with glistening white sand and mangrove-lined forests in close proximity.

Rght: Boats provide access to the surrounding islands and as an alternate way in to the mangrove forests and caves at the mouth of Kilim River. Some of the small islands are accessible at low tide.

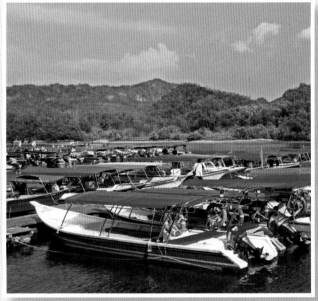

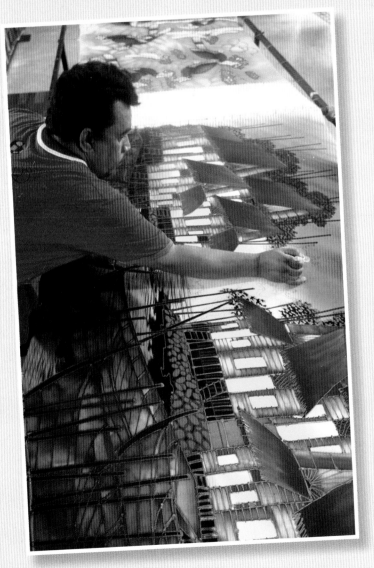

Left and above: Craft Complex (Kompleks Kraf) is a large building located on the road from Datai Bay to Tanjung Rhu. Malaysian arts and crafts, such as pewter, batik and other textiles, beads, basketry, woodcrafts, jewellery and painting are showcased with some artisans at work. Handicrafts are on sale and there is a Craft Museum as well as a Custom and Wedding Museum. The road ends at an expanse of open public beach backed by towering casuarinas and lined with local cafés and souvenir shops. This area is popular during the Friday and Saturday weekends celebrated in Langkawi.

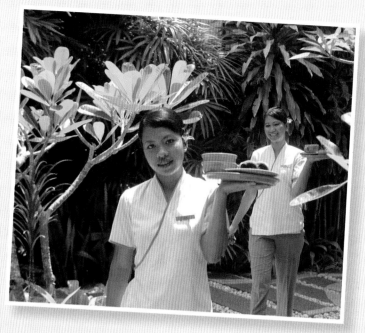

This page: There are two international resorts here; the Four Seasons Resort Langkawi (left) and the Tanjung Rhu Resort (above and below). Both are indulgent, luxurious resorts with pools, restaurants, spas and a tropical setting by the beach. The Geopark Discovery Centre in the former showcases Langkawi's natural history.

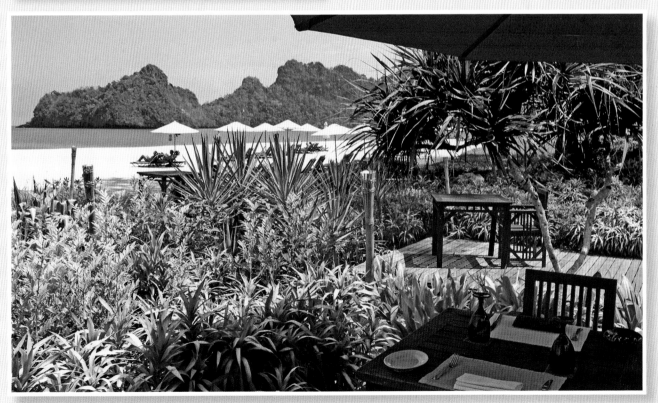

The North-east

The north-east and north-west of Langkawi are the least populated areas but of great interest for ecotourists. Coastal areas here support the most mature stands of mangroves on the island and prolific marine life. Scientific surveys have recorded 90 estuarine fish species, 50 that live in open nearshore waters plus 50 species of crabs, prawns and molluscs. These mangroves and offshore waters are very important for Langkawi's fishing industry. Three rivers drain the north-east – the Air Hangat, Kisap and Kilim. The islands of Langgun and Dendang are also ecologically interesting but rarely visited. Langkawi Wildlife Park (previously known as the Bird Park) has a variety of animals with an emphasis on birds and there is a reasonably large walk-in aviary.

Right: Gua Kelawar or the Cave of Bats is a popular stop for those who visit the mangrove forests. Formations, such as stalactites and stalagmites, can be found in the caves, which are reached by a system of boardwalks. Bats comprise the largest group of mammals in Malaysia. Insectivorous bats roost in the caves' dark recesses. They are very important in maintaining the ecological balance as many of the insects on which they feed are pests. Fruit bats are important for pollinating plants and dispersing seeds.

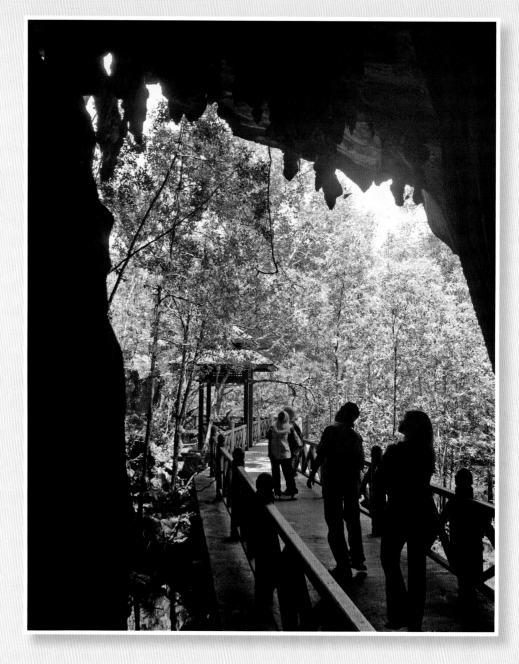

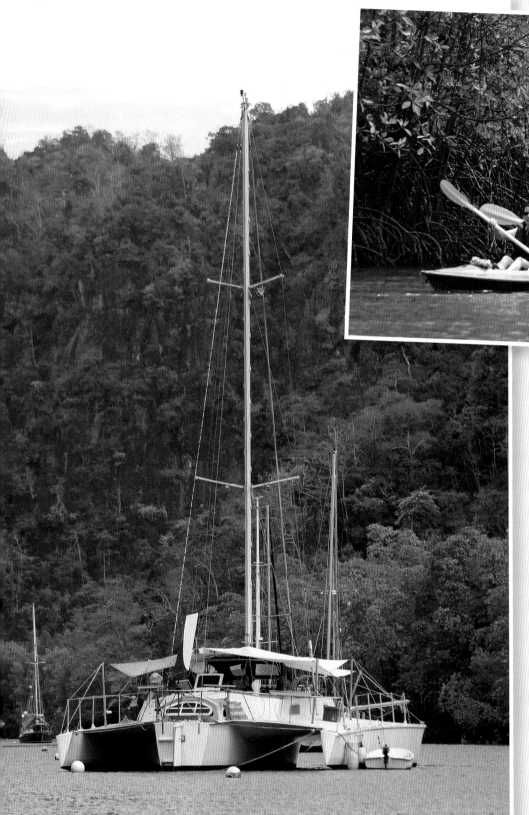

Above: Some tourists choose to kayak around the estuary and through the mangroves. Lizards, monkeys, birds and crustaceans can all be seen here.

Left: Global yachters often moor in the tranquil waters at the mouth of the Kilim River. Scenes from the 1999 Hollywood movie 'Anna and the King' were filmed here and on other parts of the island. The protected waters are ideal for a fish farm and a restaurant called the Hole in the Wall.

Opposite: Durian Perangin Waterfall is located near Telaga Air Hangat within a forested area surrounded by fruit orchards. A small suspension bridge gives access to the 14-tiered falls that are surrounded by dense rainforest. The falls are popular with locals who come to picnic and to bathe in the river.

Above: Galeria Perdana houses political gifts presented to a former Malaysian Prime Minister, Tun Dr. Mahathir Mohamad and his wife Tun Dr. Siti Hasmah. The grand building houses vintage cars, dolls, stone carvings, photographs and paintings.

Right: A traditional 17 m (56 ft) long wooden boat called Bahtera Purba from Kelantan is displayed in the grounds.

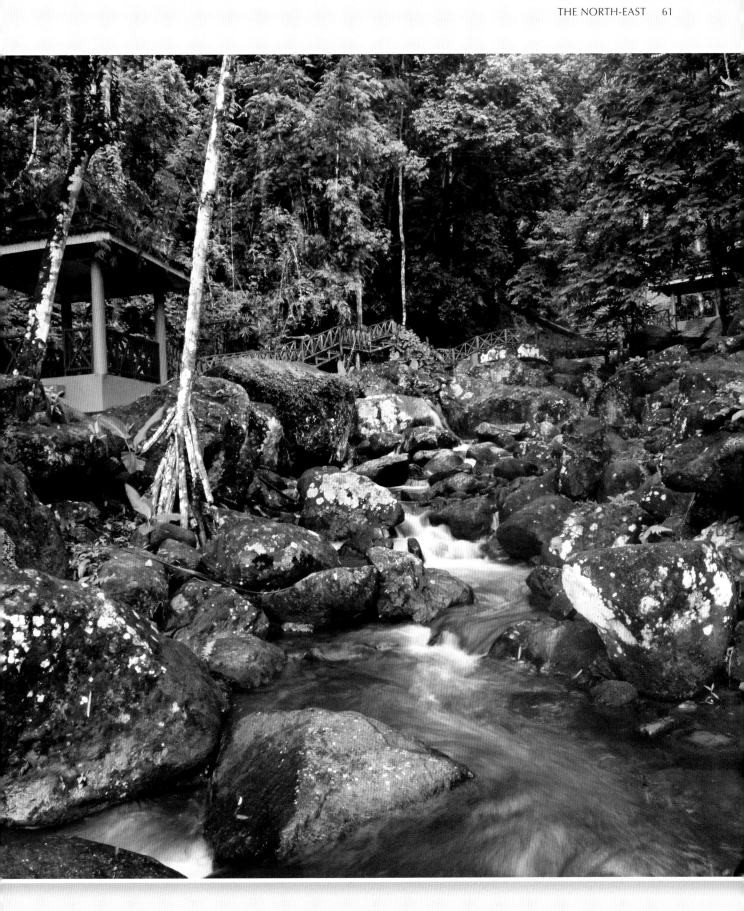

Chapter 4: Inland

Most of Langkawi's tourism infrastructure is located around the coastline with the interior being mostly covered by forests, plantations or farms and dominated by the two peaks of Mount Machincang and Raya.

Inland Langkawi and Mount Raya

While the rubber tree originates in South America, Malaysia's tropical climate is ideal for the plant to thrive here. Away from the beaches, the Langkawi interior is mostly forested or farmed with *padi* or rubber trees.

These pages: Mount Raya is not only the highest peak on the island at 880 m (2,887 ft) but also is covered in pristine rainforests that are home to some fascinating wildlife. Birdwatching is especially good here as the sealed road to the summit (opposite) passes above the rainforest canopy of trees in the valley below. Seeing hornbills, especially the Great Hornbill, makes the journey here rewarding for birdwatchers. While there are roadside stalls in the vicinity (right), a slow drive should reveal hornbills swooping above the canopy. A 4,287-step walking trail heads from Lubuk Sembilang Recreational Park to the summit but be aware it is usually overgrown and should only be attempted by experienced climbers or those accompanied by a local guide. Tree ferns and many other fern species typically grow on Mount Raya. Most grow on the forest floor but tree ferns can be several metres tall. There is a small resort at the summit that will appeal to dedicated birdwatchers who want to maximize their time at dawn and dusk looking out for birds and other animals.

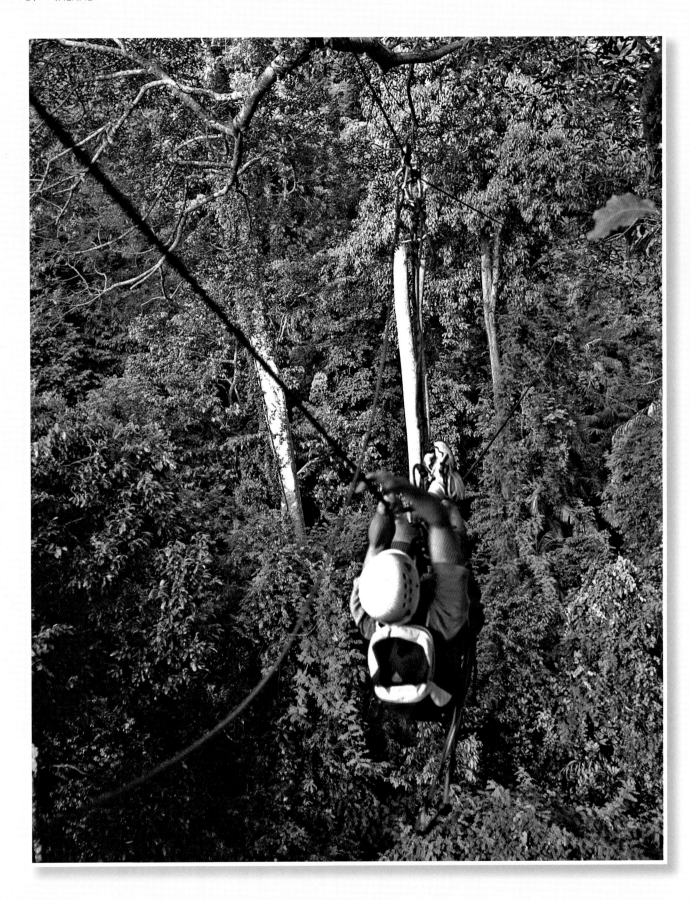

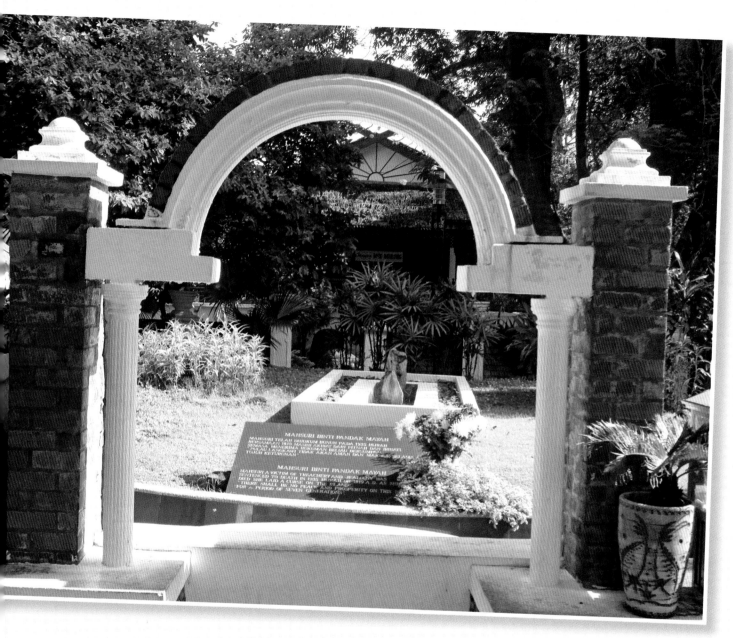

Opposite: Langkawi Canopy Adventures operate in the forests at the base of Mount Raya. The half-day activity starts from Lubuk Semilang (where a Book Village was once located) and continues via zip lines through the rainforest canopy. Participants are taught how to use the equipment and the skills required. They can then attempt a light course or the full-on, adrenaline-charged, eco adventure.

Above: The legend of Mahsuri's Curse is celebrated in the village of Kota Mahsuri which is located in a sea of 'padi' fields. It dates back some 200 years when a beautiful and kind young bride called Mahsuri supposedly committed adultery while her husband was off fighting the neighbouring Siamese (Thais). The sentence then was death using a native knife called a kris but when the time came, white blood flowed from her wound. In her last breath, Mahsuri cursed the island for seven generations and according to believers, the island has only emerged after this time to become a prospering tourism destination.

Chapter 5: Island Activities

Being an island, watersports dominate the potential activities but there is also a range of nature adventures, indulgent spa treatments, shopping, events and themed attractions to ensure a memorable visit.

Sailing, Cruising and Marinas

Langkawi is on the main sailing route from Thailand in the north and Penang, Singapore and many destinations in the South China Sea in the south. Its heritage at the crosswinds of ancient Asian trade has now been enriched with the establishment of four marinas, a ship repair yard, two leading regional yachting races and a base for a leading international yacht charter company (see pages 51 and 48 for Telaga Harbour Marina and Awana Porto Malai Marina). The winds are most favourable for sailing between November and April.

Opposite: The Rebak Island Marina is on Rebak Island which lies just off Cenang Beach. There is a modern marina, international resort and dry docking facilities for do-it-yourself yacht repairs.

Below: The Royal Langkawi Yacht Club, Langkawi's largest club, is located to the east of the Kuah Jetty and provides protected moorings to a permanent fleet plus passing yachts. An architecturally interesting clubhouse, a restaurant, bar and pool entice yachters to visit. Mooring facilities for 200 yachts enable mega yachts of 60 m (197 ft) to berth here. A ship's chandler, yacht charter company, shop and Sunsail are located here. Sunsail enables visitors to hire a fully equipped yacht with or without a skipper.

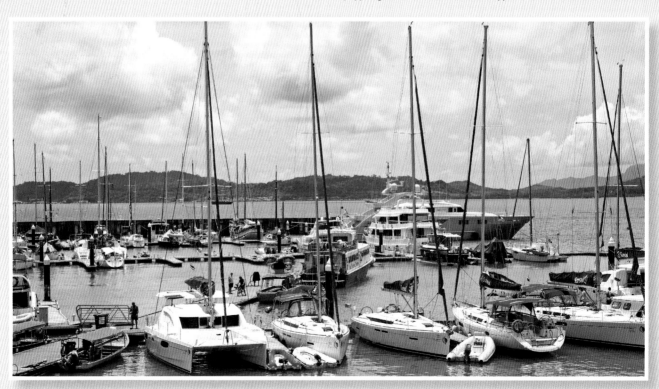

International Races

Two international yachting races attract keen yachtsmen and women to Langkawi in January and November. The Royal Langkawi International Regatta is staged at the beginning of the year with a feeder Champagne Race from Ao Chalong in Thailand to Langkawi immediately prior to the race. Most races during the six-day regatta are focussed on Kuah Harbour. The event has been held for more than a decade and attracts some 30 boats of various classes.

The Raja Muda Selangor International Regatta is a challenging nine-day offshore racing event in which the social activities in each port can be as demanding as the racing on the Straits of Malacca and Andaman Sea. The event starts at the Royal Selangor Yacht Club near Kuala Lumpur, stops at Penang and ends in Langkawi, 445 km (240 nautical miles) to the north. The regatta attracts racing yachts and classic sailing vessels and includes three days of harbour racing in Penang and Langkawi.

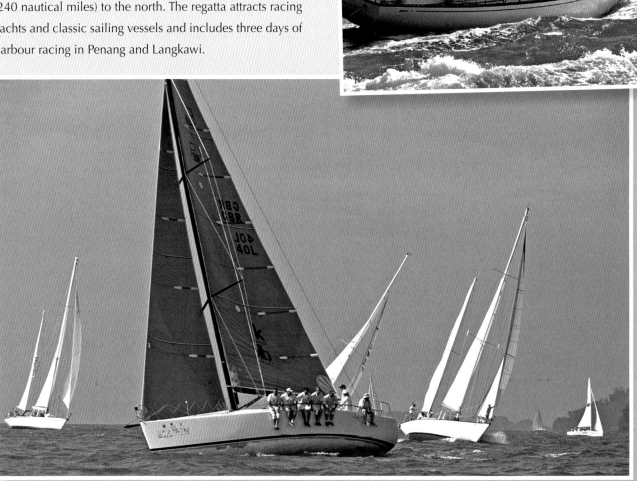

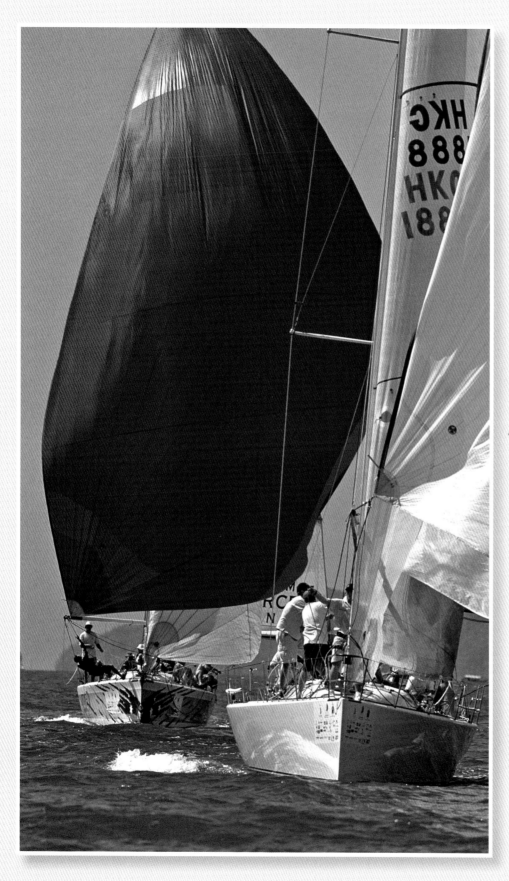

These page: Langkawi is ideally located at the northern extremity of the Straits of Malacca which are one of the world's most important waterways. They stretch 805 km (500 miles) between Peninsular Malaysia and the Indonesian island of Sumatra and connect the Indian Ocean in the north-west to the Pacific Ocean in the south-east. They have been important throughout maritime history and remain one of the world's busiest shipping lanes with over 50,000 vessels passing through here annually. Sailors use the Straits in their journeys from Thailand to Singapore, Borneo and other destinations in the Pacific.

Themed Attractions

Unlike many destinations in the region Langkawi has an abundance of natural attractions. While there is no real need to create themed attractions there are a few small to mid scale developments that attract many tourists.

Right: Crocodile Adventureland Langkawi (Taman Buaya Langkawi) houses hundreds of the reptiles from around the world that are best seen at feeding time when they are most active. 'Crocodylus porosus' is raised for its prized skin which is used to create fashion items.

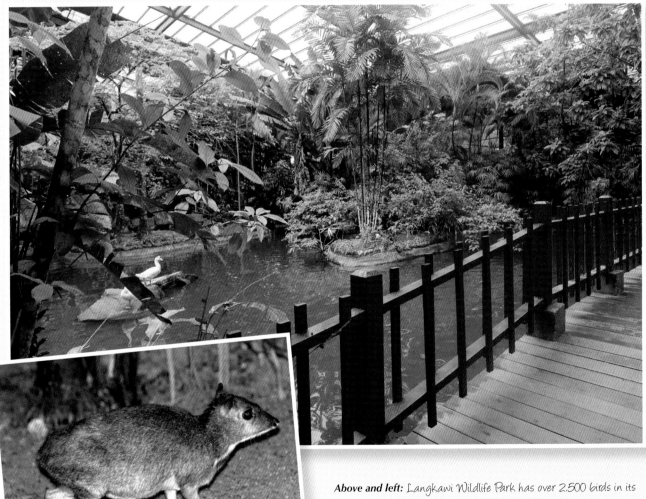

Above and left: Langkawi Wildlife Park has over 2,500 birds in its aviary. Other animals such as reptiles, Mouse Deer (pictured), crocodiles and butterflies, are also housed here. While there are local specimens, many, such as parrots, macaws and peacocks, are from overseas. There are shops and a café to complete the visit.

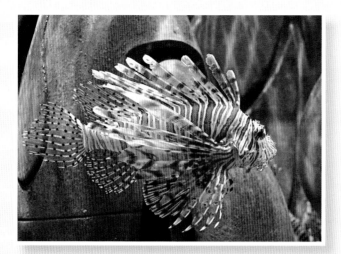

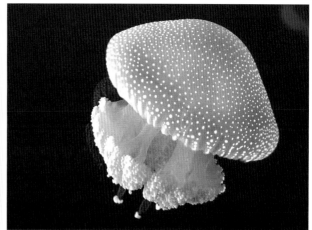

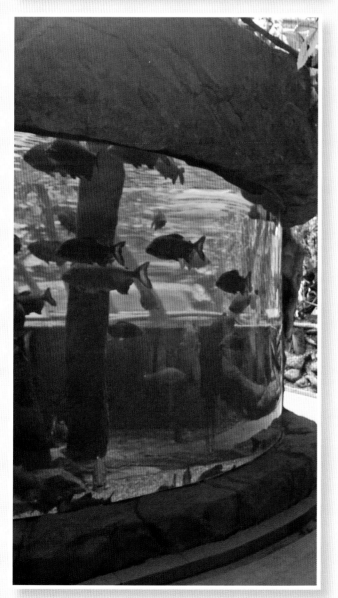

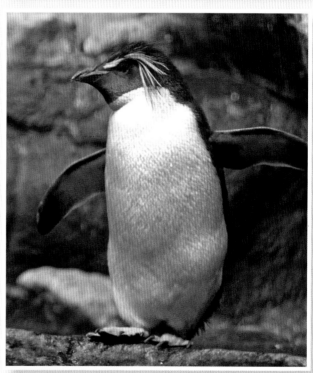

This page: Underwater World is one of the largest aquariums in Southeast Asia with over 3,000 marine and freshwater organisms. Large tanks and a walk-through tunnel enable visitors to see tortoises, sharks, rays, eels and many other species including Lionfish (top left) and the White-spotted Jellyfish (top right). Other displays include fur seals, birds, otters and reptiles. One of the most appealing displays houses Rockhopper Penguins (above) from Antarctica. There are also touch pools and koi ponds. The complex has an extensive selection of souvenirs, duty-free shopping and cafés.

Chapter 6: Beyond Langkawi Island

Most visitors only explore the main island but there are others that can be visited. Island hopping is popular and for those seeking a Robinson Crusoe experience, the smaller islands offer near solitude.

The Outer Islands

There are many islands to explore as day trips from Langkawi Island. For island hopping there are two main areas: the most popular islands are to the south while those visitors who travel to a handful of northern islands will have the islands mostly to themselves. Most half-day trips visit the southern islands for eagle viewing around Singa Besar Island, swimming along the serene beach of Beras Basah Island and lastly to Dayang Bunting Island to visit the freshwater lake.

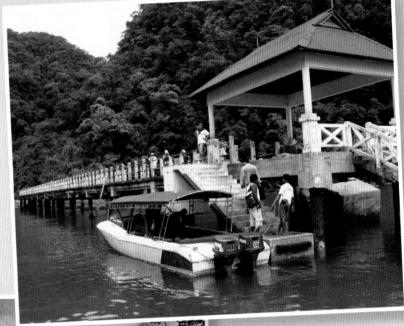

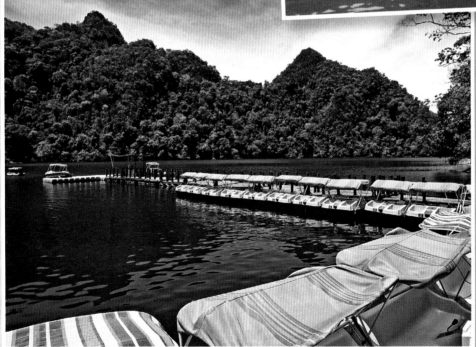

This page: Dayang Bunting Island is one of the most popular stops (above). There are two main attractions – a suspended freshwater expanse known as the Lake of the Pregnant Maiden (Tasik Dayang Bunting) (left) and the Cave of the Banshee (Gua Langsir). Langkawi's largest lake is located on limestone and is surrounded by pristine rainforest. There is minimal development although visitors come to swim in the freshwater and for various watersports.

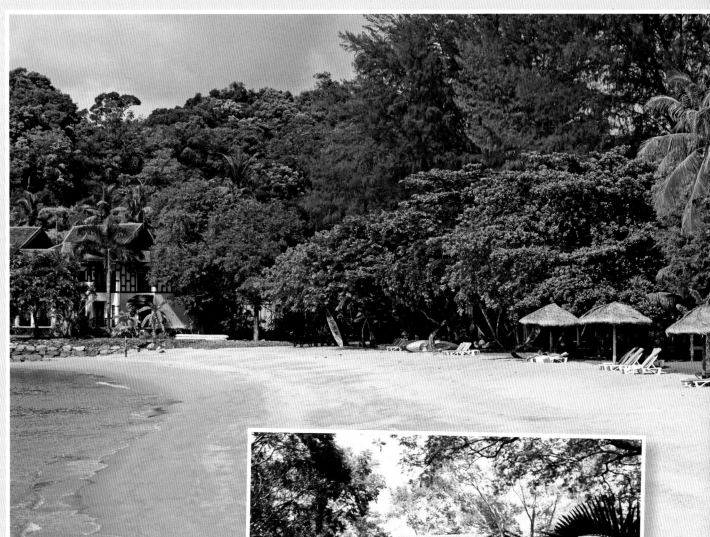

This page: Rebak Island is home to a marina and the Taj Rebak Island Resort. Along the lines of a 'one island, one resort', the Taj is for those who really want to get away from it all and yet relax knowing that the main island is just 15 minutes away by regular, fast boat services. A coconut-fringed beach and pool provide cool relief from the tropical heat and the luxury resort is fully equipped. Rebak Marina is a small protected harbour with mooring facilities for resident and visiting yachters from around the globe.

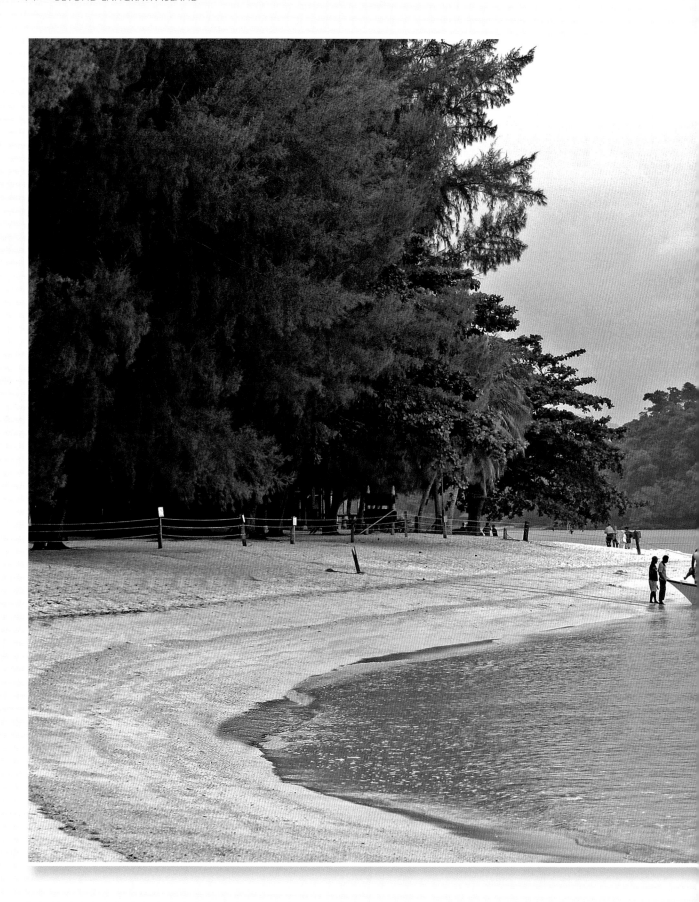

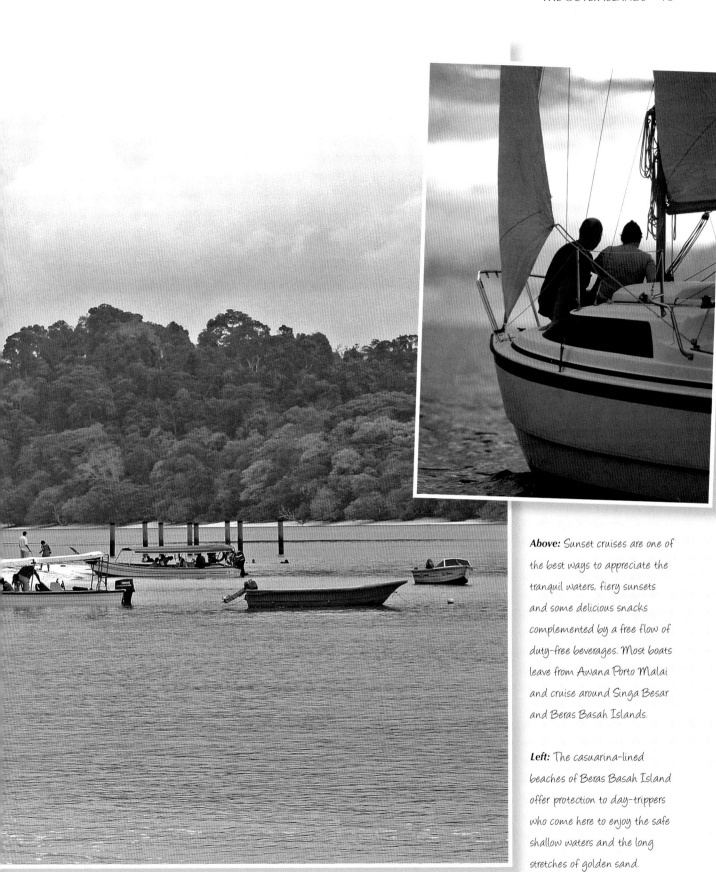

Above: Sunset cruises are one of the best ways to appreciate the tranquil waters, fiery sunsets and some delicious snacks complemented by a free flow of duty-free beverages. Most boats leave from Awana Porto Malai and cruise around Singa Besar and Beras Basah Islands.

Left: The casuarina-lined beaches of Beras Basah Island offer protection to day-trippers who come here to enjoy the safe shallow waters and the long stretches of golden sand.

Getting About

Currently four airlines operate scheduled flights to the island with some long-haul charter operators flying here mostly during the European winter. Malaysia Airlines, Firefly and AirAsia fly from Kuala Lumpur and Penang to Langkawi while Silkair offers several direct flights between Singapore and Langkawi.

Ferries operate during daylight hours from Penang Island (2 hours 30 minutes), Kuala Perlis (45 minutes) and Kuala Kedah (1 hour 15 minutes) on the mainland. Ferries also depart for Satun in southern Thailand (1 hour 15 minutes) and from Telaga Harbour to Koh Lipe in Tarutao National Marine Park (1 hour, from November to May only). Ferry services may be affected by monsoon rains.

Cruise ships occasionally berth at the large docking facility at Awana Porto Malai. Star Cruises is the main operator and cruises between Singapore and Phuket.

Above: Fast modern ferries make regular journeys to the Langkawi terminal at Kuah from two ports on the mainland as well as from Penang and Thailand.

Below: A modern cruiseliner terminal juts out from Awana Porto Malai into the Andaman Sea to provide docking facilities catering mostly to Star Cruise ships.

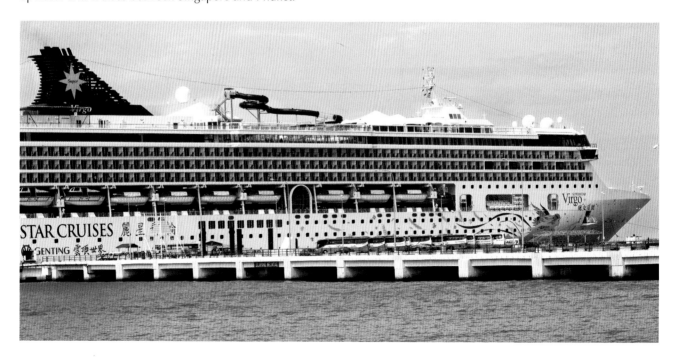

Many visitors to Langkawi choose to explore the main island in self-drive rental cars, motorbikes and bicycles. Taxis are the other option and while they do not use meters, fixed prices apply for most journeys.

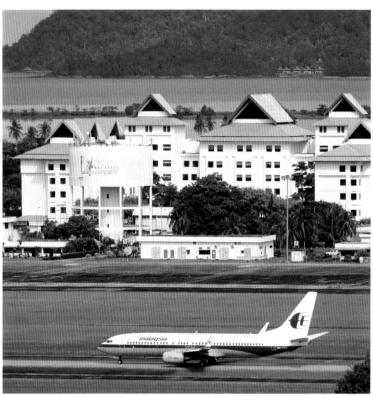

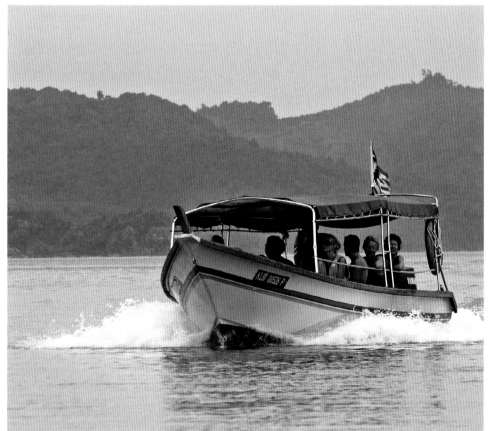

Above: Various airlines fly into Langkawi International Airport with the national carrier Malaysia Airlines providing connections to its extensive worldwide network through Kuala Lumpur.

Above left: Motorbikes for exploring the main island can be hired in all the main tourist areas.

Left: Small boats ferry tourists to the outer islands and on mangrove excursions.

Resources

Contacts

The following websites will prove useful in discovering more about Langkawi.

99 East Golf Club: www.99east.com

Asian Overland Services: www.asianoverland.com.my

Bon Ton Restaurant and Resort Langkawi:
 www.bontonresort.com

Crystal Yacht Holidays: www.crystalyacht.com

Dev's Adventure Tours: www.langkawi-nature.com

Frangipani Langkawi Resort and Spa:
 www.frangipanilangkawi.com

Gunung Raya Golf Resort: www.golfgr.com.my

Irshad Mobarak (nature guide): www.junglewalla.com

Langkawi Canopy Adventures: www.langkawi.travel

Langkawi Development Authority (LADA): www.lada.gov.my

Langkawi International Maritime and Aerospace Exhibition
 (LIMA): www.lima.com.my

Malaysian Nature Society (MNS): www.mns.my

Raja Muda Selangor International Regatta: www.rmsir.com

Tourism Malaysia: www.tourism.gov.my

Underwater World Langkawi:
 www.underwaterworldlangkawi.com.my

World Wide Fund for Nature Malaysia (WWFM):
 www.wwf.org.my

Airlines

AirAsia: www.airasia.com

Firefly: www.firefly.com.my

Malaysia Airlines: www.malaysiaairlines.com

Silkair: www.silkair.com

References

Bowden, D. 2012. *Enchanting Malaysia*. John Beaufoy
 Publishing.

Bowden, D. 2013. *Enchanting Bali & Lombok*. John Beaufoy
 Publishing.

Bowden, D., 2000. *Globetrotter Visitor's Guide Taman Negara
 - Malaysia's Premier National Park*. New Holland
 Publishers.

Davison, G.W.H. and Yeap Chin Aik. 2012. *A Naturalist's
 Guide to the Birds of Malaysia*. John Beaufoy Publishing.

Payne, J. and C. Prudente. 2010. *Wild Sabah: The Magnificent
 Wildlife & Rainforests of Malaysian Borneo*. John Beaufoy
 Publishing.

Naidu, J. N. 2002. *Langkawi A Paradise in Eco-Tourism*.
 Jantayu Publishing House.

Phillipps Q. and K. Phillipps. 2012. *Phillipp's Field Guide to
 the Birds of Borneo (2nd edition)*. John Beaufoy Publishing.

Acknowledgements

The publishers are grateful to Anthony Wong of Frangipani Langkawi Resort and Spa for making the publication of this book possible.

The author would like to thank Anthony Wong, Narelle McMurtrie from Bon Ton Resort and Irshad Mobarak for their kind assistance and keen insights on the island.

The publishers and the author would like to express special thanks to Ken Scriven for his advice and support during the preparation of this book and to Erik Fearn from Skypix (www.skypix.com.my) for the stunning aerial photographs.

About the Author

David Bowden is a freelance photojournalist based in Malaysia specializing in travel and the environment. While Australian, he's been in Asia for longer than he can remember and returns to his home country as a tourist. When he's not travelling the world, he enjoys relaxing with his equally adventurous wife Maria and daughter Zoe. He is also the author of other books in this series, *Enchanting Borneo, Singapore, Malaysia* and *Bali & Lombok*.

Index

First published in the United Kingdom in 2013 by John Beaufoy Publishing,
11 Blenheim Court, 316 Woodstock Road, Oxford OX2 7NS, UK
www.johnbeaufoy.com

10 9 8 7 6 5 4 3 2 1

ISBN 978-1-906780-94-4

Designed by Glyn Bridgewater
Cartography by William Smuts
Project management by Rosemary Wilkinson

Printed and bound in Malaysia by Tien Wah Press (Pte) Ltd.

All photos by David Bowden except for: Erik Fearn (www.skypix.com.my) (p7, p13 bottom, p36 top, p42 top,
p49 top, p50 top), Tourism Malaysia (p3 top right), Irshad Mobarak (p8, p9 top/bottom), Westin Resort (p37 top
right), Langkawi Tourism Action Council (p27 top), Shrimpz Prawn Farm (p27 bottom left), Frangipani Resort
(p45 top) and Underwater World (p71 top right).

Cover captions and credits
Back cover (left to right): *The tranquil Tengah Beach,* © David Bowden; *Attendants at the Tanjung Rhu Resort
spa,* © David Bowden; *The Awana Porto Malai marina,* © David Bowden; *The Brahminy Kite, Langkawi's mascot,*
© David Bowden. Front cover top (left to right): *The steep limestone cliffs of Kilim Geoforest Park,* © David
Bowden; *Durian Perangin waterfall,* © iStockphoto.com/Kenny Chin; *Cable car and view of Burai Bay,* © David
Bowden; *A Malay-style house at the Bon Ton Resort,* © David Bowden. Front cover (centre): *Lighthouse at Telaga
Harbour,* © Shutterstock.com/Kurt. Front cover (bottom): *Aerial view of coastline and outlying islalnds*
© Shutterstock.com/Microstock Man